EVERY
EXTREME
CLOSEUP

New media art

MARK TRIBE/REENA JANA
UTA GROSENICK (ED.)

TASCHEN

HONG KONG KÖLN LONDON LOS ANGELES MADRID PARIS TOKYO

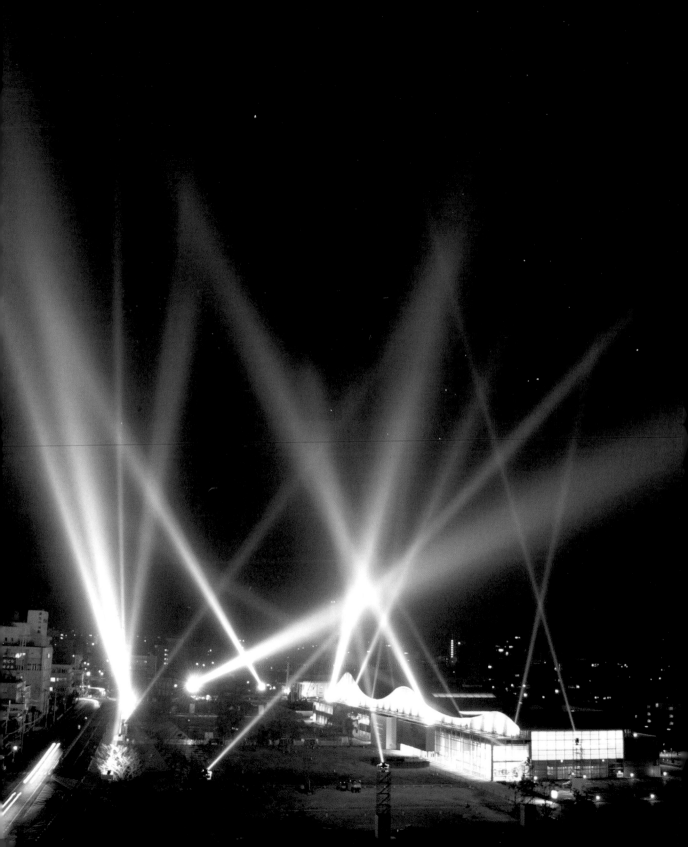

contents

Art in the age of digital distribution

"we explore the computer from inside, and mirror this on the net. when a viewer looks at our work, we are inside his computer... And we are honored to be in somebody's computer. You are very close to a person when you are on his desktop. I think the computer is a device to get into someone's mind."

Dirk Paesmans, Jodi

In 1993, at the start of the "dot com" boom, two European artists, Joan Heemskerk and Dirk Paesmans, paid a visit to California's Silicon Valley. When they returned home, they created *jodi.org*, a Web-site-as-art-work whose scrambled green text and flashing images seem to deconstruct the visual language of the Web. Heemskerk and Paesmans remixed found images and HTML scripts much as Dada artists played with the photographic imagery and typography of magazines and newspapers. *Jodi.org* changed the way many people think about the Internet, demonstrating that it didn't just provide a new way to publish information; it could also be an art medium like oil painting, photography, or video. Like other works of New Media art, *jodi.org* exploited an emerging technology for artistic purposes.

1994 was a watershed year in the linked histories of media technology and digital culture. The Netscape Corporation introduced the first commercial Web browser, signalling the Internet's transformation from a network used primarily by computer and academic researchers into a popular medium for personal communication, publishing and commerce. Terms like "the Net", "the Web", "cyberspace" and "dot com" soon became part of the international vernacular and a major societal shift appeared to be underway — from industrial production to information economies, from hierarchical organizations to distributed networks, from local markets to global ones. The Internet meant different things to different people: to entrepreneurs, it was a way to get rich quick; to activists, it was a means of building grassroots support for political causes; to media magnates, it represented a new channel for distributing content. This last group used the term "new media" to describe digital publishing forms like CD-ROMs and the Web. To "old media" companies, these nascent technologies indicated a move away from traditional outlets, such as newspapers and television, to emerging forms of interactive multimedia. In 1994, major media companies — including the Hearst Corporation, which owned numerous American periodicals and television networks — formed "new media" divisions and trade groups such as the New York New Media Association were first organized. Around the same time, artists, curators and critics started to use the term "New Media art" to refer to works — such as interactive multimedia installations, virtual reality environments and Web-based art — that were made using digital technology.

New Media art and older categorical names like "Digital art", "Computer art", "Multimedia art" and "Interactive art" are often used interchangeably, but for the purposes of this book we use the term New Media art to describe projects that make use of emerging media technologies and are concerned with the cultural, political and aesthetic possibilities of these tools. We locate New

1950 — Engineering Research Associates of Minneapolis built the ERA 1101, the first commercially produced computer

1954 — First meeting of SHARE, a group of IBM users

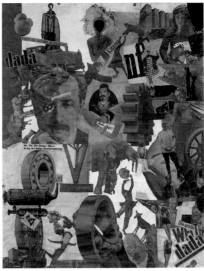

Media art as a subset of two broader categories: Art and Technology and Media art. Art and Technology refers to practices, such as Electronic art, Robotic art and Genomic art, that involve technologies which are new but not necessarily media-related. Media art includes Video art, Transmission art and Experimental Film – art forms that incorporate media technologies which by the 1990s were no longer new. New Media art is thus the intersection of these two domains. We chose to limit the scope of this book to work that was made after the term New Media art was broadly adopted in 1994 and to focus on works that are particularly influential, that exemplify an important domain of New Media art practice and that display an exceptional degree of conceptual sophistication, technological innovation, or social relevance.

Deciding what counts as media technology is a difficult task. The Internet, which is central to many New Media art projects, is itself composed of a heterogeneous and constantly changing assortment of computer hardware and software – servers, routers, personal computers, database applications, scripts and files – all governed by arcane protocols, such as HTTP, TCP/IP and DNS. Other technologies that play a significant role in New Media art include video and computer games, surveillance cameras, wireless phones, hand-held computers and Global Positioning System (GPS) devices. But New Media art is not defined by the technolo-gies discussed here; on the contrary, by deploying these technologies for critical or experimental purposes, New Media artists redefine them as art media. In the hands of RSG, for example, data surveillance software, similar to that used by the United States' Federal Bureau of Investigation (FBI), becomes a tool for artistic data visualization. In addition to exploring the creative possibilities of this software, RSG develops a critique of surveillance technology and its uses.

art-historical antecedents

Although New Media art is, on one level, all about the new – new cultural forms, new technologies, new twists on familiar political issues – it did not arise in an art-historical vacuum. The conceptual and aesthetic roots of New Media art extend back to the second decade of the 20th century, when the Dada movement emerged in several European cities. Dada artists in Zurich, Berlin, Cologne, Paris and New York were disturbed by what they perceived as the self-destructive bourgeois hubris that led to the First World War. They began to experiment with radically new artistic practices and ideas, many of which resurfaced in various forms and references throughout the 20th century. Much as Dada was in

1954 — Early computer music performance at MoMA by the founders of Computer Music Center at Columbia University

1963 — ASCII is first used **1964 — Marshall McLuhan's book "Understanding Media" is published**

3. RSG

Prepared PlayStation
2005, manipulated commercial video game

4. ROY LICHTENSTEIN

M-Maybe
1965, magna on canvas, 152 x 152 cm
Cologne, Museum Ludwig

5. THOMSON AND CRAIGHEAD

Trigger Happy
1998, web-based video game

3

part a reaction to the industrialization of warfare and the mechanical reproduction of texts and images, New Media art can be seen as a response to the information technology revolution and the digitization of cultural forms.

Many Dadaist strategies reappear in New Media art, including photomontage, collage, the readymade, political action and performance – as well as Dada artists' provocative use of irony and absurdity to jar complacent audiences. Fragmented juxtapositions of borrowed images and texts in works like Shu Lea Cheang's *Brandon* and Diane Ludin's *Genetic Response 3.0* (2001) are reminiscent of the collages of Raoul Hausmann, Hannah Höch and Francis Picabia.

Marcel Duchamp's readymades prefigured countless New Media art works involving blank appropriation, from Alexei Shulgin's *WWWArt Award* to RSG's *Prepared PlayStation* (2005). The work of George Grosz, John Heartfield and other Berlin Dadaists who blurred the boundaries between art and political action serve as important precedents for activist New Media art projects like Electronic Disturbance Theater's *FloodNet* and Fran Illich's *Borderhack* (2000–2005). The performances of Emmy Hennings, Richard Huelsenbeck and others at the Cabaret Voltaire in Zurich set the stage for New Media performance artists such as Alexei Shulgin and Cary Peppermint. And echoes of Hugo

Ball's absurdist sound poems can be heard in radioqualia's *Free Radio Linux*.

Pop art is another important antecedent. Like Pop paintings and sculptures, many works of New Media art refer to and are engaged with commercial culture. Much as Pop artist Roy Lichtenstein reproduced comic book images in his paintings, the New Media artist duo Thomson and Craighead sampled a video game (Space Invaders) in *Trigger Happy* (1998). Lichtenstein's meticulous emulation of the Benday dots used in comic books and other contemporary print media anticipates the work of artists like eBoy, who painstakingly construct images pixel by pixel. By reproducing images from comic books, advertisements and magazines in "high art" media like oil paint on canvas, Pop artists ultimately distanced themselves from the popular culture that inspired them. In contrast, New Media artists tend to work with the very media from which they borrow (e. g. games) rather than transposing them into forms that fit more neatly within art world conventions.

Whereas Pop art was strongly invested in the craft of making paintings and sculptures, Conceptual art, also a significant precursor to New Media art, focused more on ideas than on objects. New Media art is often conceptual in nature. John F. Simon, Jr.'s *Every Icon* (1996), for example, includes a Java applet

1966 — E.A.T. (Experiments in Art and Technology, Inc.): performances by Robert Rauschenberg and Billy Kluver, e. g.
1967 — Sony releases the PortaPak, the first portable video camera

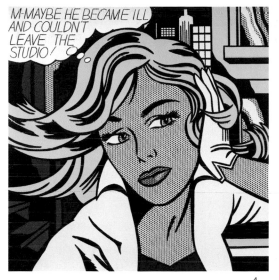

The coming into being of the notion of "author" constitutes the privileged moment of individualisation in the history of ideas, knowledge, literature, philosophy, and the sciences. Even today, when we reconstruct the history of a concept, such categories seem relatively weak.

4

5

(a small programme that runs in a Web browser) that is programmed, over the course of many trillions of years, to run through every possible image that can be formed within a 32 x 32 grid. Much as Lawrence Weiner's "Indefinite Material Descriptions" (e.g. *One Quart Exterior Industrial Enamel Thrown on a Brick Wall*, 1964) don't need to be realized to exist as art works, Simon's *Every Icon* doesn't need to be seen (or completed) to be understood.

New Media art has strong parallels to Video art as well. The emergence of Video art as a movement was precipitated by the introduction in the late 1960s of the portable video camera, or PortaPak. Previously, Video art had been practiced by a few pioneers (most notably Nam June Paik). The availability of relatively inexpensive video equipment caught the attention of artists like Joan Jonas, Vito Acconci, William Wegman, Bill Viola and Bruce Nauman. A generation later, the introduction of the Web browser catalyzed the birth of New Media art as a movement. New Media artists saw the Internet much as their predecessors saw the portable video camera: as an accessible artistic tool that enabled them to explore the changing relationship between technology and culture.

New media art as a movement

While the art of the 1970s was defined by distinct movements (e.g. Conceptual art, Feminist art, Land art, Media art, Performance art), the 1980s gave rise to an overheated art market and a plethora of micro-movements. Many of these, such as Neo-Expressionism and Neo-Conceptualism, were postmodern recuperations of previous moments in art history. After the art market crash that followed "Black Monday" (October 19, 1987, the day the United States' stock markets collapsed), these micro-movements lost their momentum and, by the early 1990s, had largely run their course, leaving a conspicuous void (although trends, such as identity politics and large-scale photography, could be identified). Fed by the growth of Masters of Fine Arts programmes and supported by the expansion of museums, contemporary art continued to thrive, but artistic practices did not cohere into definable movements. Painting was declared dead by critics, collectors and artists alike, as video and installation came to dominate international museum and biennial exhibitions. It was against this background of extreme fragmentation that New Media art emerged at the end of the 20th century.

From 1994 until 1997, when Net art was first included in the documenta X exhibition in Kassel, Germany, New Media art

1968 — "Cybernetic Serendipity" exhibition on view at the Institute of Contemporary Art, London
1970 — The exhibition "Software" at the Jewish Museum, New York, treats computer programming as a metaphor for conceptual art

"software design has a very sculptural quality."

Mark Napier

6

existed in relative isolation from the rest of the art world. Email lists and Web sites served as alternative channels for the discussion, promotion and exhibition of New Media art work, enabling artists to form an online art scene that straddled the worlds of contemporary art and digital culture.

Because of its close connection to the Internet, however, from its inception New Media art was a worldwide movement. The Internet facilitated the formation of communities without regard for geography. The international nature of the New Media art movement reflected the increasingly global nature of the art world as a whole, as evidenced by the proliferation in the 1990s of international biennial exhibitions, including the Johannesburg Biennial and the Gwangju Biennial.

This shift was part of a much larger historical trend: the globalization of cultures and economies. Globalization was both a cause and an effect of the widespread use of the Internet, wireless telephones and other information and communication technologies. The emergence of a "global village" of the sort that Marshall McLuhan predicted in his 1962 book "The Gutenberg Galaxy" created unprecedented demand for these technologies, driving their rapid development and deployment. They also enabled globalization by facilitating international trade, multinational partnerships and the free exchange of ideas. New Media art

reflected these developments and explored their effects on society, much as video art served as a lens through which to understand television and its role in an increasingly media-centric culture.

Advances in personal computing hardware and software also played a significant role in the emergence of New Media art as a movement in the 1990s. Although personal computers had been on the market for more than a decade (the popular Apple Macintosh was introduced in 1984), it wasn't until the mid-1990s that affordable personal computers were powerful enough to manipulate images, render 3D models, design Web pages, edit video and mix audio with ease. Equally important, the first generation of artists to have grown up with personal computers and video games (in the 1980s) was coming of age. These young artists were as comfortable with new media as they were with more traditional cultural forms.

Beginnings

For all these reasons — the emergence of a global art scene, advances in information technology and the familiarity of computing to a rising generation — artists were drawn to New Media art from other disciplines. Previously, computer-based art had been a

1971 — Floppy diskette invented by IBM

1972 — Atari video game company debuts with Pong

1974 — Nam June Paik coins the term "information superhighway"

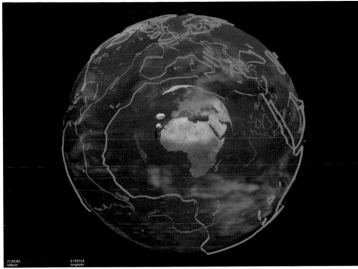

6. MARK NAPIER
<u>FEED</u>
2001, website

7. JOHN KLIMA
<u>Earth</u>
2001, website

marginal field practised primarily by a small cadre of dedicated pioneers. The confluence of factors outlined above, along with a general sense of excitement and fascination with the potential of new technologies, created an unprecedented level of interest in new media on the part of painters, performance artists, activist artists, filmmakers, conceptual artists, etc. Whether fuelled by dot-com era enthusiasm or critical of what media theorist Richard Barbrook called the "California Ideology" (a heady cocktail of libertarianism and technological utopianism exemplified by the editorial voice of "Wired" magazine), artists around the world started to work with emerging media technologies in ways that were informed by the conceptual and formal qualities of their former disciplines. The painter Mark Napier, for example, who worked by day as a database software programmer for Wall Street financial firms, demonstrated his compositional sensibilities and his interest in colour in such early Internet-based works as *Shredder 1.0*.

For many artists, the advent of the Internet meant that computers were no longer merely tools for manipulating images, designing invitations to gallery shows and writing grant applications. Suddenly, computers became a gateway to an international community of artists, critics, curators, collectors and other art enthusiasts. Although some artists used the Internet as a way of disseminating documentation of work made in other media (e.g.

by putting a portfolio of scanned photographs on the Web), others approached the Internet as a medium in its own right or as a new kind of space in which to intervene artistically.

In 1995, a Slovenian artist named Vuk Cosic encountered the phrase "net.art" in a garbled email message. Although the period, or "dot", was eventually dropped, the term "Net art" quickly caught on among artists and others in the nascent New Media art scene and became the preferred label for Internet-based artistic practices. It was not a coincidence that the term originated in Eastern Europe; many important artists in the early history of Net art were located there, like Alexei Shulgin and Olia Lialina, both based in Moscow. After the fall of the Iron Curtain and the collapse of the Soviet Union, artists in that region had a unique perspective on the Internet's dot-com era transformation – they were living in societies making the transition from Socialism to Capitalism, a phenomenon that in many ways mirrored the privatization of the Internet.

Compared to other forms of New Media art, Net art was relatively inexpensive to produce, and therefore more accessible to artists with limited financial means. Many of the core technologies, such as the Apache Web server and Hypertext Markup Language (HTML), were available for free. All an artist needed to make Net art, besides ideas and technical skills, was a computer (even an

1976 — Steve Wozniak and Steven Jobs form the Apple Computer Company
1977 — Apple II is released, as is Tandy TRS-80 (which sells 10,000 units in first month on market)

8

"in the wake of sept 11, are games too 'real'? or is the real converging with the simulation?"

Anne-Marie Schleiner

8. ALLAN KAPROW

<u>18 Happenings in 6 Parts</u>
1959, Reuben Gallery, New York

9. MARCEL DUCHAMP

<u>Fountain</u>
1917/1964, porcelain urinal, 33 x 42 x 52 cm
Stockholm, Moderna Museet

10. MICHAEL MANDIBERG

<u>AfterSherrieLevine.com</u>
2001, website

old one would do), a modem and an Internet connection. Although such connections were expensive for those who lived in countries where local telephone charges were high, many New Media artists found ways to access the Internet for free through public libraries, universities and corporations. For many New Media artists, like John Klima, day jobs as programmers or Web site designers provided access to the tools of production (computer hardware and software), speedy Internet connections, and, in some cases, valuable training.

Because it dovetailed with the rise of the Internet and concomitant cultural and economic shifts, Net art played a key role in the New Media art movement, but it was by no means the only type of New Media art practice. Other significant genres include Software art, Game art, New Media installation and New Media performance, although individual projects often blur the boundaries between these categories. Many works of Game art, for example, use Web-based technologies and are meant to be experienced online. Natalie Bookchin's *The Intruder* is simultaneously a work of Game art and a work of Net art, as is *Velvet-Strike* by Anne-Marie Schleiner, Brody Condon and Joan Leandre.

collaboration and participation

New Media artists often work collaboratively, whether in ad-hoc groups or in long-term partnerships. Like films or theatrical productions, many New Media art projects – particularly the more complex and ambitious ones – require a range of technological and artistic skills to produce. The development of RSG's *Carnivore*, for example, involved the participation of several programmers, and numerous artists and artist groups have been invited to contribute to the project by building interfaces. Sometimes, however, the motivation to collaborate is more ideological than practical. By working in collectives, New Media artists challenge the romantic notion of the artist as a solitary genius. Eleven of the 35 artists and groups discussed in the main section of this book identify themselves collectively. This is the case with ®™ark, an artist group whose members used assumed names and a corporate identity as part of an elaborate critique of the special protections corporations receive under United States law. Other New Media art groups that work under a shared name include the Bureau of Inverse Technology, Fakeshop, Institute for Applied Autonomy, Mongrel and VNS Matrix.

The New Media art movement continued an art-historical shift from passive audience reception to active participation that

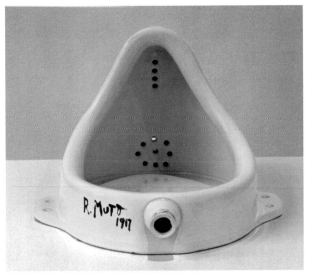

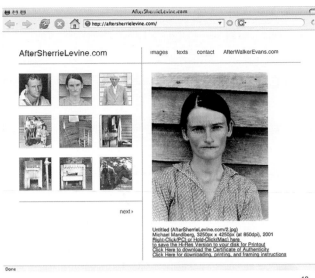

was previously exemplified by the Happenings of the 1960s and 1970s. In Allan Kaprow's seminal *18 Happenings in 6 Parts* (1959), for example, audience members were directed to specific seats in various rooms of the exhibition venue, where they followed strictly choreographed movements at particular times.

Many New Media art works, such as Jonah Brucker-Cohen's and Katherine Moriwaki's *UMBRELLA.net* and Golan Levin et al's *Dialtones: A Telesymphony*, involve audience participation. Other works of New Media art require audience members to interact with the work but not to participate in its production. Interactive New Media art responds to audience input but is not altered by it. Audience members may click on a screen to navigate through a web of linked pages or activate motion sensors that trigger computer programmes, but their actions leave no trace on the work itself. Each member of the audience experiences the piece differently based on the choices he or she makes while interacting with the work. In Olia Lialina's *My Boyfriend Came Back From the War*, for example, visitors click through a series of frames on a Web page to reveal images and fragments of text. Although the elements of the story never change, the way the story unfolds is determined by each visitor's own actions.

From appropriation to open source

Artists have always influenced and imitated one another, but in the 20th century various forms of appropriation, from collage to sampling, emerged as an alternative to ex nihilo creativity. Enabled by technologies of mechanical reproduction, artists began to use found images and sounds in their work. Hannah Höch's Dadaist photomontages, Marcel Duchamp's readymades, Andy Warhol's Pop art *Brillo Boxes*, Bruce Connor's Found Footage films and Sherrie Levine's Neo-conceptual remakes all reflected the changing status of artistic originality in the face of mass-produced culture.

In New Media art, appropriation has become so common that it is almost taken for granted. New media technologies such as the Web and file-sharing networks gave artists easy access to found images, sounds, texts and other media. This hyperabundance of source material, combined with the ubiquitous "copy" and "paste" features of computer software, further eroded the notion that creating something from scratch is better than borrowing it. In *After Sherrie Levine* (2001), New Media artist Michael Mandiberg takes appropriation to an almost absurd extreme. In 1979, Sherrie Levine re-photographed Walker Evans' classic Depression-era photographs of an Alabama sharecropper family. Mandiberg scanned images from a catalogue featuring Levine's photographs of Evans'

1983 — MIDI (Musical Instrument Digital Interface) debuts at the first North American Music Manufacturers show in Los Angeles
1984 — William Gibson's novel "Neuromancer" is published, coining the phrase "cyberspace"

13

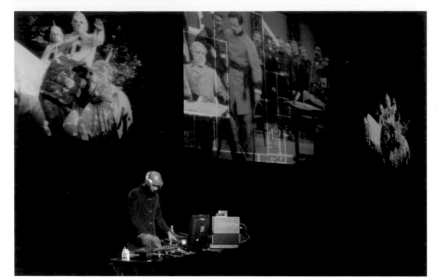

11. **PAUL D. MILLER AKA DJ SPOOKY**
<u>Rebirth of a Nation</u>
2004, multimedia performance,
Chicago, Museum of Contemporary Art

12. **ON KAWARA**
<u>June 2,1971</u>
1971, Liquitex on canvas, 25.4 x 33 cm,
from *Today Series*, since 1966
Private collection

13. **MTAA**
<u>OnKawaraUpdate</u>
2001, website

11

work, and posted them on the Web at AfterSherrieLevine.com. As part of an "explicit strategy to create a physical object with cultural value, but little or no economic value", Mandiberg invited visitors to print the images along with certificates of authenticity and specific framing instructions.

As appropriation became an increasingly important artistic strategy, the intellectual property laws and policies that govern access to found material grew ever more restrictive. In the 1990s and 2000s, movie studios, the recording industry and other corporate content owners became more and more concerned about the unauthorized copying and distribution of their assets. They lobbied successfully to extend copyright terms and to make it illegal to circumvent copyright protection measures (e.g. the encryption schemes that accompany DVDs). These corporations also moved aggressively to police copyright violations, for example by pursuing legal action against individuals who illegally shared music online. The resulting tension between artistic practices and the intellectual property regime led New Media artists, musicians and other cultural practitioners to look for alternative models for authoring and sharing their work. They found a model in open source software, an approach to developing computer applications in which a programme's source code is made freely available to a distributed network of programmers who develop features and fix problems. Like New Media art, open source software involves collaboration, relies on the Internet, and depends on a gift economy in which altruism and "ego boo", or the peer-recognition that motivates programmers and artists alike, are the primary motivators. New Media artists who adopt open source principles tend to appropriate found material, to collaborate with other artists and to make their own work available to others on a share-and-share-alike basis. Examples of this approach include Cory Arcangel's *Super Mario Clouds*, RSG's *Carnivore*, Raqs Media Collective's *OPUS*, 0100101110101101.ORG's *Life Sharing* and radio-qualia's *Free Radio Linux*.

While rooted both in Duchamp's assisted readymades and Pop art's recycling of everything from advertisements to comic books, New Media art remixes are also influenced by the sampling and remixing practices of popular music, particularly hip-hop and electronic dance music. These genres involve not only the borrowing and recombining of musical fragments, but also the production of new versions of familiar songs through the addition of new elements and the rearrangement of existing ones. Like popular hip-hop tracks, certain works of New Media art, such as Olia Lialina's *My Boyfriend Came Back From the War*, have been remixed again and again. Some New Media artists even go so far as to remix their own work. In *BUST DOWN THE DOOR AGAIN!*

1985 — Massachusetts Institute of Technology's Media Lab is founded 1988 — Inter-Society for the Electronic Arts (ISEA) holds its first symposium 1989 — ZKM (Center for Art and Media), a New Media art museum and research institute, founded in Karlsruhe, Germany

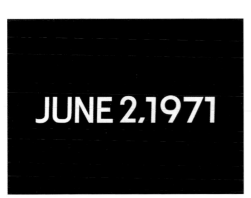

JUNE 2,1971

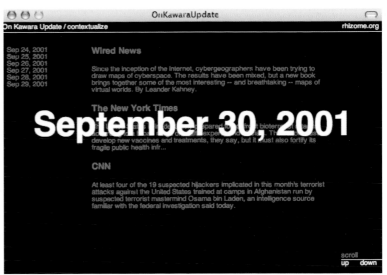

GATES OF HELL-VICTORIA VERSION, YOUNG-HAE CHANG HEAVY INDUSTRIES replaces the original work's background, alters the text colour, changes the soundtrack and adds a Korean translation.

The interdisciplinary convergence of popular music and New Media art is explored in various ways by Paul Miller aka Dj Spooky That Subliminal Kid, an influential DJ, writer and artist. Miller exemplifies the remix sensibility in *Rebirth of a Nation* (2002), a series of live performances in which he reworks D.W. Griffith's controversial 1915 film "Birth of a Nation" while assembling an improvised soundtrack out of layers of sampled sound.

Early New Media artists were sometimes criticized for their lack of art-historical knowledge and for overlooking their work's relationship to such precedents as Dada, Pop art and Media art. But many New Media artists consciously reflect art history in their work, reinterpreting or updating projects from the 1960s and 1970s in the context of a new technological environment. MTAA's *OnKawaraUpdate* (2001), for example, uses a software programme to mimic the concept and aesthetic of Conceptual artist On Kawara's date paintings. In *Empire 24/7*, Wolfgang Staehle uses a live Web camera projection to remake Andy Warhol's *Empire* (1964), an eight-hour long film of the Empire State Building. John F. Simon, Jr. revisits Paul Klee's experimental use of the

Cartesian grid in *Every Icon* (1996). And Jennifer and Kevin McCoy use databases to reinterpret films in such projects as *201: A Space Algorithm* (2001), their version of Stanley Kubrick's "2001: A Space Odyssey" (1968). Along with a penchant for collaboration and a marked tendency to appropriate rather than to create from scratch, this media-archeological approach to art-making exemplifies the attenuation of authorial originality in New Media art.

A fascination with the past also manifests itself in the work of New Media artists who mine or mimic obsolete digital media technologies. Cory Arcangel's *Super Mario Clouds* is a nostalgic take on the video game Super Mario Brothers. Natalie Bookchin's *The Intruder* and Keith and Mendi Obadike's *The Pink of Stealth* also pay homage to early video games. In *386 DX*, Alexei Shulgin uses an outdated personal computer to perform covers of classic pop songs. This aesthetic of obsolescence and crudeness, sometimes known as "dirt style", stands in contrast to the clean lines and slickness of much commercial New Media art and design.

1990 — World Wide Web makes its debut 1990 — Tim Berners-Lee develops HTML 1990 — Robert Riley organizes
"Bay Area Media", an exhibition that features several works of computer-based art, at the San Francisco Museum of Modern Art

14. FRAN ILLICH

<u>Borderhack</u>
2005

15. VITO ACCONCI

<u>Step Piece</u>
1970, performance at 102 Christopher Street,
New York

16. MICHAEL DAINES

2000, Daines attempted to sell his body under
eBay's sculpture category

"The only thing art actually does is break
the patterns and habits of perception.
Art should break open the categories and
systems we use in order to get through
life along as straight a line as possible."

Cornelia Sollfrank

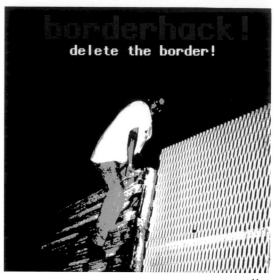

14

corporate parody

 The Web enabled Amazon.com, a startup bookseller, to grow into a retail giant, and it empowered bloggers to compete with major news organizations as a source for information and opinion. The Web also made it easy for New Media artists to produce on-line presences that convincingly mimicked the aesthetics and rhetoric of corporate sites, complete with logos, brand names and slogans. In *Airworld* (1999), for example, Jennifer and Kevin McCoy created an ersatz corporation, complete with a logo, Web site and uniforms. They built a software bot that crawled the Web looking for corporate marketing jargon and used the found text as fodder for an audio Web cast and a low-power radio transmission. The artists also sampled corporate surveillance camera feeds and persuaded an online advertising company to donate thousands of ad banner impressions to promote the site and the Airworld brand.

 Multi-disciplinary artist Miltos Manetas hired Lexicon Branding, the firm that invented such brand names as "PowerBook" and "Pentium", to coin a term for a "new type of theory, art, architecture, music and life style, influenced by computers". Of the several terms Lexicon suggested, Manetas chose "Neen", announcing his selection at a press conference at the Gagosian Gallery in New York. The art group ®™ark developed Web sites and organized performative actions and pranks that critiqued corporate culture by emulating it.

Hacking and hacktivism

 In mainstream newspapers, Hollywood films and other popular media, hackers are usually portrayed as computer whiz kids who break into others' computers to steal information or simply to wreak havoc. But this notion is only partially correct. Within hacker circles, such attacks are known as cracking and are frequently frowned upon. According to computer scientist Brian Harvey, a hacker is "someone who lives and breathes computers, who knows all about computers, who can get a computer to do anything. Equally important… is the hacker's attitude. Computer programming must be a hobby, something done for fun, not out of a sense of duty or for the money… A hacker is an aesthete." In Harvey's view, a hacker is actually more like an artist than a criminal. Although some hackers use their skills maliciously, in the hacking community there is a widely recognized moral code, the "hacker ethic", which holds that the sharing of information is an overriding good and that hackers should contribute to the

1991 — The Thing, a BBS for artists, founded 1991 — Linux 0.01 debuts 1993 — "Wired" magazine debuts
 1994 — Netscape goes public 1995 — artnetweb founded in New York

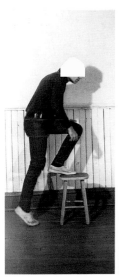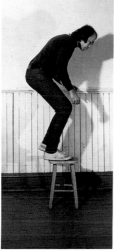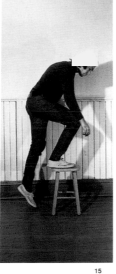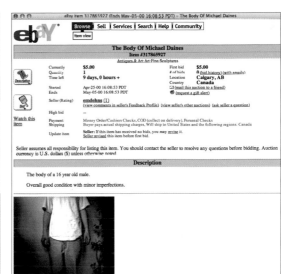

15

16

advancement of their field by writing open source software and enabling access to knowledge and computer resources.

In his 2004 book "A Hacker Manifesto", McKenzie Wark extends the notion of hacking to other domains, including the realm of art, and likens it to innovation. He writes, "Whatever code we hack, be it programming language, poetic language, math or music, curves or colourings, we create the possibility of new things entering the world… In art, in science, in philosophy and culture, in any production of knowledge where data can be gathered, where information can be extracted from it and where in that information new possibilities for the world are produced, there are hackers hacking the new out of the old." Many New Media artists see themselves as hackers or use hacking as concept or content in their work. These include Cory Arcangel, Knowbotic Research and Critical Art Ensemble, whose project *Child as Audience* (2001) included a CD-ROM with instructions on how to hack into and alter Game Boy video games.

The latter two groups exemplify the activist approach of many hacker artists. This blend of hacking and political activism is often called "hacktivism". Artist and theorist Cornelia Sollfrank has written about hacking as a metaphor for cultural production and cultural production as a form of hacking. For her Cyberfeminist project *Female Extension*, Sollfrank worked with hackers to develop a software programme that generates works of Net art by sampling and remixing elements from existing Web sites. To expose the sexism that she believes pervades contemporary curatorial practices, she then submitted more than 200 of these works to an international Net art competition under false female names, thus ensuring that a majority of the entrants were women. When the jury announced the three winners, all of whom were men, Sollfrank revealed her intervention.

The advent of the Internet has made it feasible for artists and others to organize international grassroots movements and to engage in electronic civil disobedience actions. In *Zapatista Tactical FloodNet*, Electronic Disturbance Theater initiated a symbolic "denial of service attack", or the disabling of a Web site by overwhelming its server with traffic, against various corporate and institutional Web sites including those of Chase Manhattan Bank and the office of former Mexican President Ernesto Zedillo. This action was intended as a peaceful act of protest against the Mexican government's unfair treatment of indigenous Mexicans.

1995 — The Whitney Museum of American Art becomes the first museum to acquire a work of Net art: Douglas Davis' "The World's First Collaborative Sentence" (1994) **1995 — Dia Center for the Arts launches Artists' Web Projects programme**

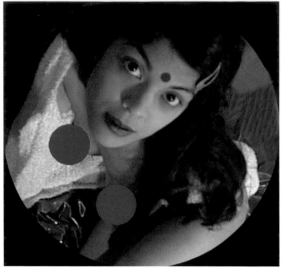

17 18

interventions

For many New Media artists, the Internet is not only a medium but also an arena in which to intervene artistically – an accessible public space similar to an urban sidewalk or square where people converse, do business or just wander around. Part of the appeal of this space is that it is outside the museum-gallery complex, and thus gives artists access to a broad, non-art audience. In *Velvet-Strike*, for example, Anne-Marie Schleiner, Joan Leandre and Brody Condon staged interventions within Counter-Strike, a popular networked computer game in which players engage in urban battle. *Velvet-Strike*'s audience includes both members of the international New Media art community and the players of Counter-Strike, many of whom resented the intervention, which involved manipulating onscreen characters to act in nonviolent ways rather than engage in conflict.

Many artists have intervened in eBay, the massive online auction site, by offering unusual things for sale. In 2000, Michael Daines, then a 16-year-old high-school student in Calgary, attempted to sell his body under eBay's sculpture category. By treating his body as a sculptural object, this project recalls the work of Eleanor Antin, Chris Burden, Gilbert & George and other Performance artists who used their bodies as a medium in their work. The following year, also on eBay, Keith Obadike put his African-American racial identity up for auction in *Blackness for Sale* (2001), echoing the slave auctions of previous centuries. In the description field on his eBay auction page, Obadike included a list of benefits and warnings that were by turns humorous (e.g. "This Blackness may be used for gaining access to exclusive, 'high risk' neighborhoods") and trenchant (e.g. "The Seller does not recommend that this Blackness be used while making intellectual claims"). The hacktivist art group ®™ark also used eBay to auction off their individual tickets to an exclusive party connected with the 2000 Whitney Biennial exhibition, both to raise funds for future projects and to make the point that, in the art world, money can buy access.

Other New Media artists intervene in physical public spaces. In *Pedestrian*, Paul Kaiser and Shelley Eshkar project computer-generated animations onto urban sidewalks and public plazas. In *BorderXing*, Heath Bunting and Kayle Brandon document their attempts to cross international borders illegally by posting digital photographs and diaristic texts on a Web site. Torolab's *Vertex Project* (1995–2000) is a proposal for a footbridge across the Tijuana/San Diego border. Equipped with billboard-sized screens, the bridge would serve as a public gallery for images, texts and other media submitted via a nearby computer.

1996 — Webby Awards and International Academy of Digital Arts and Sciences (IADAS) founded 1996 — Polaroid releases a 1-megapixel digital camera 1996 — Eyebeam founded in New York 1996 — Rhizome.org founded in Berlin

17. PREMA MURTHY

<u>Bindigirl</u>
1999, website

18. HARWOOD@MONGREL

<u>Hogarth, My Mum 1700–2000</u>
2000, from the on-line project
Uncomfortable Proximity
London, Tate Modern

19. EDUARDO KAC

<u>Rara Avis</u>
1996, robots, cameras, birds

19

identity

Many New Media artists have used the Internet as a tool to explore the construction and perception of identity. The Internet makes it easy for an artist to create a fictive online persona merely by setting up a free email account or home page. Race, gender, age, sexual orientation and nationality can all be invented, undermining the notion that art works are authentic expressions of their makers' identities. *Mouchette.org*, a Net art project that claims to be the work of a 13-year-old girl named Mouchette (after the protagonist of 1967 film by Robert Bresson about an adolescent girl), demonstrates the pliability and uncertainty of online identity. As visitors explore the site, it becomes clear that Mouchette is a fictional invention. Yet the character's presence, the sense that there really is a girl named Mouchette behind the project, remains convincing. As of this writing, the true identity of the artist responsible for Mouchette has yet to be revealed.

Other New Media artists address issues of identity in more straightforward ways. Shu Lea Cheang's *Brandon*, for example, explores the true story of Teena Brandon, a young woman who was murdered for passing as a man. In *Bindigirl* (1999), Prema Murthy represents herself as an Indian pinup girl in a critique of the Internet pornography industry and the Orientalism found in

Asian pornography. The artist group Mongrel has explored issues of identity, particularly race, in several projects, including *Uncomfortable Proximity* (2000). In this work, Harwood, one of the group's members, altered images on the Web site of Tate Britain, one of England's leading art museums. Harwood combined portraits by British painters, including Thomas Gainsborough, William Hogarth and Joshua Reynolds, with images of Harwood's friends and family to create his own version of art history and, through the process, conjure up an alternative vision of British identity.

telepresence and surveillance

The Internet and other network technologies both bridge and collapse geographical distances. This is particularly evident in the use of devices such as Web cams and remote-controlled robots that produce the effect of telepresence, or experience at a distance. Ken Goldberg's *Telegarden*, for example, enables people from around the world to tend to the flowers and plants of a garden by controlling a robotic arm via online commands. Similarly, Rafael Lozano-Hemmer's *Vectorial Elevation* allows Web site visitors to manoeuvre robotic spotlights from afar, creating patterns in the sky above public plazas. Other artists working with the con-

1997 — Fondation Daniel Langlois pour l'art, la science et la technologie founded in Montreal
1997 — The Walker Art Center in Minneapolis launches Gallery 9, a commissioning programme and extensive online gallery of New Media art

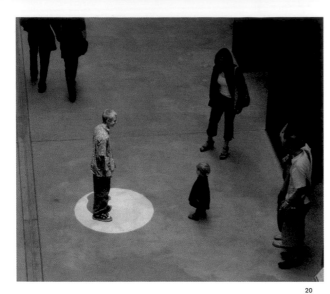

20. MARIE SESTER

<u>ACCESS</u>

2003, interactive multimedia installation

21. JAMES BUCKHOUSE IN COLLABORATION WITH HOLLY BRUBACH

<u>Tap</u>

2002, PDA-based interactive animation, commissioned by Dia Center for the Arts for its series of artists web projects at www.diaart.org

22.

<u>Gallery 9</u>

The Walker Art Center's online exhibition space

cept of telepresence do so in more localized situations. In Eduardo Kac's *Rara Avis* (1996), for example, a robotic parrot with a camera behind its eyes is placed inside an aviary along with real birds. Gallery visitors control the parrot's movements via remote controls, experiencing an avian point of view on a small screen fitted within a headset.

Since the mid-20th century, surveillance has been an increasingly significant subject of literature, cinema and art. From George Orwell's novel "1984", first published in 1949, to Francis Ford Coppola's 1974 film "The Conversation", surveillance typically has been portrayed as a menacing spectre of government or corporate power. By the end of the 20th century, however, cultural attitudes toward surveillance had become more ambivalent. While concerns about the invasion of privacy remained, surveillance was also seen as a necessary evil, protecting the innocent from threats of abuse, crime, or terrorism. Surveillance began to appear not only as a technology of military and police control but also as a form of entertainment. In Web sites like JenniCAM, in which a young woman installed Web cameras in her home to expose her everyday actions to online viewers, and Reality television shows like "Big Brother", in which contestants volunteered to subject themselves to around-the-clock public observation, surveillance became a source of voyeuristic and exhibitionistic excitement.

This shift paralleled a dramatic rise in the sophistication and pervasiveness of such surveillance technologies as networked cameras, biometric identification systems, satellite imaging and data mining.

Institutional surveillance and the invasion of privacy have been widely explored by New Media artists. Ken Goldberg's *Demonstrate* (2004), for example, uses a telerobotic video camera and an interactive Web site to allow people to observe activity at the University of California at Berkeley's Sproul Plaza, a birthplace of the Free Speech movement in the 1960s. Marie Sester's *ACCESS* (2003) casts a beam of light on those who pass beneath its electronic eye. Sester uses image recognition technology to identify individual figures, singling them out in crowds and tracking them as they move about. An acoustic beam system directs whispered voices that only the tracked subject can hear. *ACCESS* evokes both the searchlights trained on prison escapees and the spotlights shone on theatrical performers.

The institutional embrace

By the early 1990s, New Media art had begun to attract the interest of museums, galleries, funders and other art institutions,

1997 — The international contemporary art exhibition documenta X features Net art prominently in a separate "Hybrid Workspace" section
1997 — InterCommunication Center opens in Tokyo 1997 — The ZKM Center for Art and Media opens

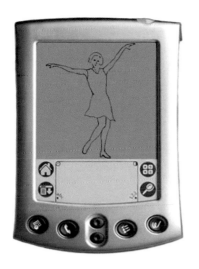

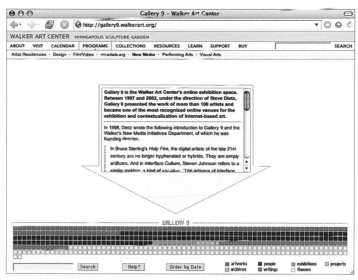

21

22

despite widespread scepticism among proponents of more traditional forms, like painting and sculpture. Some cultural institutions, however, were already familiar with computer-based art. In the early 1970s, around the same time that Video art was beginning to gain critical and curatorial support, a handful of exhibitions of computer-based art work appeared in mainstream museums on both sides of the Atlantic. In 1968, the Institute of Contemporary Art (ICA) in London organized "Cybernetic Serendipity", a show that explored how computer-driven automatons and other technological devices were used in traditional art-making, including poetry, painting and sculpture. That same year, the exhibition "Software" at the Jewish Museum in New York treated computer programming as a metaphor for conceptual art. A year later, the Los Angeles County Museum of Art (LACMA) featured a show of work produced in LACMA's Art and Technology programme, an initiative that matched contemporary artists like Robert Irwin, Robert Rauschenberg and Richard Serra with major corporations to realize art projects. This brief curatorial trend came to an end in the mid-1970s as members of the counterculture (many of whom were artists and curators) came to associate technology with corporate capitalism and the Vietnam War.

Art museums then largely ignored digital and electronic art until the early 1990s, shortly before the rise of the New Media art movement. In 1990, Robert Riley, a curator in the Media arts department of the San Francisco Museum of Modern Art (SFMoMA), organized "Bay Area Media", an exhibition that featured several works of computer-based art. These included Lynn Hershman's *Deep Contact* (1990), an interactive installation about seduction and illusion in which viewers navigated through a series of video segments via a touch-sensitive screen, and Jim Campbell's *Hallucination* (1988–1990), which merged live video of museum-goers with stored footage of fire. In 1993, Jon Ippolito, an associate curator at the Guggenheim Museum in New York, organized "Virtual Reality: An Emerging Medium", an introduction to artistic uses of a technology that was the focus of much attention both in the mainstream media and in the Art and Technology world at that time.

In the mid-1990s, support for New Media art broadened as curators responded to the dot-com era enthusiasm for new media and to the quality and quantity of the work that was being produced. In 1995, the Whitney Museum of American Art became the first museum to acquire a work of Net art: Douglas Davis' *The World's First Collaborative Sentence* (1994), a Web site where visitors could add to an endless string of words. Also in 1995, New York's Dia Center for the Arts launched its Artists' Web Projects programme, which commissioned both established con-

1998 — Netscape announces that it will make its source code freely available to the public
1998 — The Web becomes truly worldwide when the last 21 nations come online

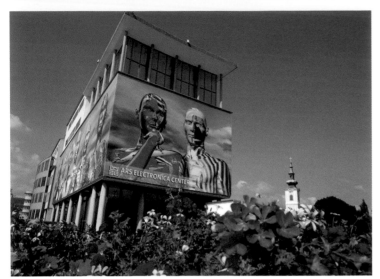

23.

<u>Ars Electronica Center</u>
Linz, Austria, exterior view

24.

<u>The Thing</u>
In 1991, German sculptor Wolfgang Staehle founded
The Thing, an electronic bulletin board system (BBS)
that functioned as a forum for artists and cultural
theorists. In 1995, Staehle migrated The Thing to the
World Wide Web.

23

temporary artists (like Cheryl Donegan, Tony Oursler and Francis Alÿs) and emerging New Media artists (such as James Buckhouse, Kristin Lucas and Olia Lialina) to produce works of Net art. In 1996, the Walker Art Center in Minneapolis launched Gallery 9, an ambitious commissioning programme and extensive online gallery of New Media art, under the guidance of the influential curator Steve Dietz. In 1997, the international contemporary art exhibition documenta X featured Net art prominently in a separate "Hybrid Workspace" section. In an irreverent act characteristic of early Net art's anti-art-world attitude, Vuk Cosic appropriated the documenta Web site, displaying a copy on his own server.

From this point, institutional interest in New Media art expanded significantly. By the late 1990s, other art institutions, including London's ICA, New York's New Museum of Contemporary Art and Paris' Fondation Cartier, among others, supported the exhibition of New Media art. In January 2000, the Whitney appointed Christiane Paul, who founded the New Media art journal "Intelligent Agent", as adjunct curator of digital art, and the same month, SFMoMA appointed Benjamin Weil, co-founder of the Net art Web site äda 'web, as curator of media arts.

Later that year, the Whitney Biennial – considered a barometer of trends in contemporary American art – included nine works of Net art, such as Ken Goldberg's *Ouija 2000* (2000) and Mark Amerika's *Grammatron* (1997). The following year, the Whitney staged "Bitstreams", a museum-wide exhibition of art involving digital processes, including New Media art as well as painting, photography and sculpture. At the same time, SFMoMA presented a similarly ambitious exhibition: "010101: Art in Technological Times". That summer, the Slovenian Pavilion at the 49th Venice Biennale featured a work of New Media art, *Biennale.py*, a computer virus developed by 0100101110101101.ORG in conjunction with the collective epidemiC. Even New York's Metropolitan Museum of Art began to collect New Media art, acquiring *Every Shot/Every Episode* (2000) by Jennifer and Kevin McCoy in 2002.

Independent initiatives

While many New Media artists sought and received the institutional imprimatur of museum exhibitions, others were indifferent to the art world and its power brokers. This latter group preferred to work outside the mainstream contemporary art world, instead working within the communities and institutions of the Media art and Art and Technology fields, where their work was more widely understood. Media art had grown out of the

1999 — AOL acquires Netscape for $4.2 billion

1999 — "net_condition" exhibition at the ZKM Center for Art and Media in Karlsruhe

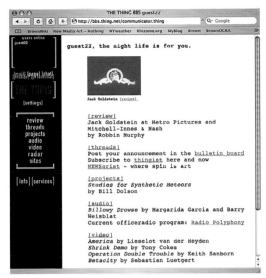

> **"The functionality of a computer is an aesthetic quality: the beauty of configurations, the efficacy of software, the security of system, the distribution of data, are all characteristics of a new beauty."**
>
> Franco Mattes, 0100101110101101.ORG

Video art movement that started to develop in the mid-1960s, and Art and Technology had been a subject of study since the late 1970s at such academic programmes as New York University's Interactive Telecommunications Program, founded in 1979, and the Massachusetts Institute of Technology's Media Lab, founded in 1985.

Festivals and conferences devoted to Art and Technology had long existed in Europe, thanks mainly to a tradition of generous government support for the arts. The most notable of these are the Ars Electronica festival in Linz, Austria, which was first held in 1979, and the Inter-Society for the Electronic Arts (ISEA), which organized its first symposium in 1988. In 1997, the ZKM Center for Art and Media, a major New Media art museum and research institute, opened in Karlsruhe, Germany. Asia, too, was a site for institutional support for Art and Technology: in 1997, for example, the InterCommunication Center, a museum of New Media art, opened in Tokyo, supported by the Japanese telephone company, NTT. Other major corporate supporters of Art and Technology in Japan included Canon and Shiseido, both of which supported art labs in the 1990s.

In the United States, a number of small, non-profit organizations sprouted up in New York and other cities, starting in the mid-1990s. Online communities formed by New Media artists, such as artnetweb, Rhizome.org and The Thing (all headquartered in New York), were established as virtual spaces for the display, discussion and documentation of New Media art, playing a key role in the international movement's evolution. Physical spaces for New Media art followed in the late 1990s and early 2000s. These included Eyebeam Atelier and Location One in New York and Art Interactive in Cambridge, Massachusetts. Smaller New Media art organizations appeared in Europe as well. Notable examples include Internationale Stadt and Micro in Berlin, C3 in Budapest, Ljudmila in Ljubljana and [plug.in] in Basel.

Fuelled by evidence of growing international institutional support, government agencies and private foundations began to fund New Media art in the late 1990s. Leading public supporters of New Media art included the Arts Council in the United Kingdom, the Canada Council for the Arts, the Mondriaan Foundation in the Netherlands, the United States' National Endowment for the Arts and the New York State Council on the Arts. Private funders included the Andy Warhol Foundation, Creative Capital, the Fondation Daniel Langlois pour l'art, la science et la technologie, the Ford Foundation, the Jerome Foundation, and the Rockefeller Foundation. Despite the strength of this support, there remained many arts funders and other established institutions that were not interested in New Media art.

2000 — American stock markets crash, marks end of dot-com bubble 2000 — Whitney Biennial includes Net art 2001 — The Whitney Museum of American Art stages the exhibition "Bitstreams", including New Media art as well as painting, photography and sculpture

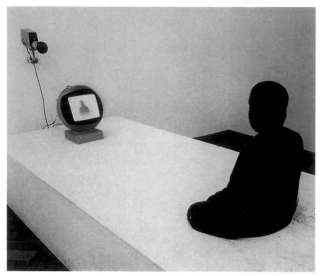

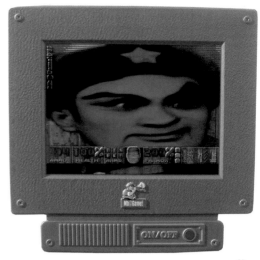

25 26

Of course, many artists continued to operate independently, in essence carrying on in the initial, anti-establishment spirit of the New Media art movement. Artists working with emerging technologies often used personal Web sites, email lists or other forms of media dissemination to establish and maintain an international presence and a global audience without the help of galleries, museums or other institutions.

Many New Media artists were profoundly sceptical of the art market, the notion of commercializing art and market economies in general. The formative years of the New Media art movement followed the end of the Cold War, and these artists were critical of capitalism and the victory of free-market ideology symbolized by the dissolution of the Soviet Union. In addition, Left-leaning artists also saw in the Internet an opportunity to realize progressive, anti-capitalist ideals that seemed threatened by the collapse of Communism. In the early years of New Media art, critics, curators and artists used the term "gift economy" to describe the way in which New Media art was circulated. Rather than selling and buying works of art, members of the New Media art community generally preferred to exchange work for free via Web sites, email lists, alternative spaces and other venues. This free sharing was similar both in spirit and in practice to the way in which open source software was distributed.

collecting and preserving new media art

The inherently ephemeral nature of much New Media art, as well as its often unfamiliar aesthetics and technologies, posed a challenge to gallerists and collectors. Some artists provide a CD-ROM or other storage device containing a copy of the work (e. g. the sale of a floppy disk containing Douglas Davis' *The World's First Collaborative Sentence* to collectors in 1995). Others produce works that take the form of physical objects, such as John F. Simon, Jr.'s wall-mounted "art appliances", which recall framed paintings. Feng Mengbo's Iris prints from his interactive CD-ROMs and Cory Arcangel's silk-screens of images from his Game art works, have had commercial success, partly because such forms are familiar and relatively easy to exhibit.

Despite the anti-commercial attitude of many New Media artists and the technological hurdles of presenting their work in galleries, some dealers have sustained significant New Media art programmes. Notable examples include Bitforms Gallery in New York and Seoul, Postmasters Gallery, Sandra Gering Gallery and Bryce Wolkowitz Gallery in New York and GIMA in Berlin.

Because of its often immaterial nature and its reliance on software and equipment that rapidly becomes obsolete and unavailable, New Media art is particularly difficult to preserve. Just

2002 — Metropolitan Museum of Art buys "Every Shot/Every Episode" by the McCoys
2003 — New Museum affiliates with Rhizome.org

"I approach coding like it is a kind of creative writing. I do not start with a flow chart. I start with a simple loop and then observe how the small changes in the code affect the visual result. I never plan exactly what the code will do and more often than not end up incorporating something the code did in testing that I had not anticipated."

John F. Simon, Jr.

25. NAM JUNE PAIK

<u>TV Buddha</u>
1974, monitor, camera, statue
Amsterdam, Stedelijk Museum

26. FENG MENGBO

<u>I'm a Tiger!</u>
1997, silk-screen print on aluminum panel,
40 x 40 cm

27. JOHN F. SIMON, JR.

<u>A-life</u>
2003, software, altered computer monitor

27

as most of Eva Hesse's latex sculptures from the 1960s and '70s have deteriorated, many works of New Media art will soon be beyond repair. In 2001, a consortium of museums and arts organizations founded the Variable Media Network. These included the Berkeley Art Museum/Pacific Film Archives in Berkeley, Franklin Furnace, the Guggenheim Museum and Rhizome.org in New York, the Fondation Daniel Langlois pour l'art, la science et la technologie in Montreal, the Performance Art Festival + Archives in Cleveland and the Walker Art Center in Minneapolis. Dedicated to finding ways to preserve works made with non-traditional, ephemeral materials, such as Nam June Paik's video installations, Felix Gonzalez-Torres' piles of give-away candies and Mark Napier's Net art works, the Network has developed a number of case studies and publications, and a questionnaire that organizations can use to gather preservation-related information from artists. Notable strategies for preserving works of New Media art include documentation (e.g. taking screen shots of Web pages), migration (e.g. replacing outdated HTML tags with current ones), emulation (software that simulates obsolete hardware) and recreation (reproducing old work using new technology).

At the time of writing, it remains unclear whether New Media art has run its course as a movement. Artists have always experimented with emerging media, reflecting on and complicating the relationships between culture and technology and will certainly continue to do so. The explosion of creativity and critical thought that characterized New Media art from the mid-1990s to the early 2000s shows no sign of slowing. But as the boundaries separating New Media art from more traditional forms like painting and sculpture grow less distinct, New Media art will likely be absorbed into the culture at large. Like Dada, Pop and Conceptual art, it may end as a movement but live on as a tendency – a set of ideas, sensibilities and methods that appear unpredictably and in multiple forms.

2004 — Google goes public; its IPO fetches $1.7 billion

2005 — U.S. Supreme Court holds that peer-to-peer software manufacturers can be held liable when people use their wares to infringe copyright

Life sharing

Debian GNU/Linux, HTML, JavaScript, Flash, Python
Keywords: locative, open source, network, privacy
http://0100101110101101.org/home/life_sharing

Much as an office with its books, correspondence and files reflects the interests and activities of its occupant, so, too, can the contents of a personal computer be seen as an intimate portrait of its owner. Because our computers contain so much personal information, we protect them from prying eyes with passwords, firewalls and encryption software.

In *Life Sharing*, a project commissioned by the Walker Art Center in Minneapolis, the European New Media art duo 0100101110101101.ORG (Eva and Franco Mattes) turned their private lives into a public art work. From 2000 to 2003, they made each and every file on their computer, from grant proposals to incoming emails, available to anyone at any time via their Web site. This daring piece, whose title is an anagrammatic play on the term "file sharing", is an exercise in transparency, an act of data exhibitionism on the part of the artists that turns viewers into voyeurs.

In *Life Sharing*, 0100101110101101.ORG demonstrates a willingness to make themselves profoundly vulnerable (in terms of potential identity theft and other online violations) in the name of art. They use their digital identities as a medium, much as such 1970s Performance artists as Linda Montano, Vito Acconci and Chris Burden used their physical bodies in their work. Visitors to the *Life Sharing* site encountered a graphical representation of a Linux directory structure – a point-and-click version of the open source operating system's text-based interface. Instead of guarding their intellectual property, the artists shared it with anyone who was interested, much as the authors of Linux software make their source code public. *Life Sharing* was not 0100101110101101.ORG's first radical experiment with intellectual property. In 1999, they downloaded contents of the private art Web site Hell.com and made all of it publicly available on the 0100101110101101.ORG site – a hacktivist intervention that garnered the ire of many of the artists' peers and brings to mind earlier examples of appropriationist art such as Sherrie Levine's reproductions of Walker Evans' photographs.

As a sequel to *Life Sharing*, 0100101110101101.ORG created *Vopos*, a project in which the artists wore Global Position-ing System (GPS) transmitters to track their whereabouts, mapping their location on their Web site in real time. The artists also patched their mobile phone conversations through their server so anyone could listen in. A recording of their conversations was then remixed by Negativland, an art collective whose sound collages have led to multiple law suits for copyright infringement.

Vopos and *Life Sharing* were elements of a larger project dubbed *Glasnost*, a reference to Mikhail Gorbachev's policies of openness that led, albeit indirectly, to the collapse of the Soviet Union. According to the artists, in *Glasnost* "0100101110101101.ORG is trying to give an account of how vast amounts of personal information are moving into corporate hands, where it can be developed into electronic profiles of individuals and groups that are potentially far more detailed and intrusive than the files built up in the past by state police and security agencies". In response to this Orwellian spectre of corporate data collection, 0100101110101101.ORG turned their Web site into a virtual glasshouse, applying the principles of open source software to open their lives to the public eye.

> **"A computer, with the passing of time, ends up looking like its owner's brain. It does it more and better than other more traditional media, e. g., diaries, notebooks or, on a more abstract level, paintings and novels."**
>
> **0100101110101101.ORG**

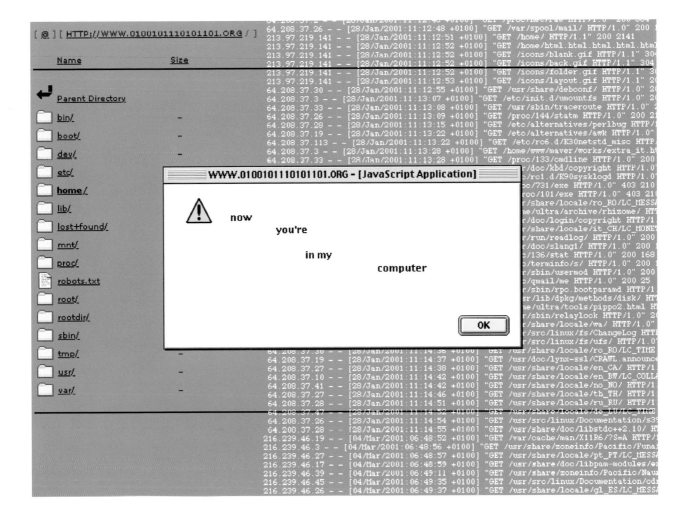

super mario clouds

ART EEPROM burner, DASM 6502 BSD, data projectors, NBASIC BSD, Nintendo Entertainment System, RockNES, Super Mario Brothers Nintendo cartridge, video distributor
Keywords: animation, appropriation, game, nostalgia
http://www.beigerecords.com/cory/21c/21c.html

According to Cory Arcangel, "hobbyists are the true heroes of contemporary computer art". He is referring to a thriving sub-culture of self-taught programmers who make music and art with obsolete consumer technologies like video game cartridges and dot matrix printers. To make *Super Mario Clouds*, Arcangel hacked Super Mario Brothers, a classic video game that made its debut in 1985. He replaced the programme chip from an old Nintendo Entertainment System game cartridge with a new chip that he programmed himself (by borrowing code he found on computer hobby scene Web sites) to erase everything in the original game except the clouds.

Arcangel has exhibited the resulting animation as large-scale digital projections in which the pixellated clouds, rendered in white and gray, scroll across a bright blue sky. He also made an edition of silk-screened prints of the clouds, which he sold on his Web site. Arcangel's empyreal imagery suggests art-historical references, from John Constable's 19th-century cloud studies in oil on canvas to conceptual artist Vik Muniz' *Clouds* (2001), in which the artist hired a skywriting airplane to draw cartoony nimbuses in the sky above Manhattan. Arcangel's process of visual subtraction evokes Robert Rauschenberg's *Erased de Kooning Drawing* (1953), in which the artist famously erased a composition by Willem de Kooning to create a new work of art. *Super Mario Clouds* suggests a similar sensibility, simultaneously conveying a stripped-down aesthetic and a rebellious, bad-boy attitude that challenges conventional notions of artistic integrity and authenticity.

Although hacking video games could be seen as a fundamentally subversive act, suggesting an anti-corporate attitude on the part of the artist, this work is more playful than critical. Arcangel seems to take appropriation almost for granted, as if sampling the intellectual property of game companies and other computer programmers were the default mode of authorship. He works with Beige Records, an "electronic music recording company and computer programming ensemble", publishes his source code online (complete with humorous and informative comments) and gives performative how-to lectures.

While many new media artists fetishize emerging technologies, Arcangel eschews the graphic realism of contemporary game titles like Grand Theft Auto, celebrating instead the crude "dirt style" imagery of early video games. *Super Mario Clouds* was created at a moment in contemporary art when nostalgia for childhood and adolescence was a prevalent theme, from Sue de Beer's videos of suburban teenagers, to Yoshitomo Nara's paintings that resemble storybook pages filled with cute renditions of puppies and baby-faced imps. *Super Mario Clouds* also evokes the nerdy culture of Arcangel's own teenage years, exemplified in such 1980s movies as "Weird Science" and "Revenge of the Nerds", in which awkward young men created outlandish machines to fulfill their fantasies or to empower themselves and gain respect from their peers.

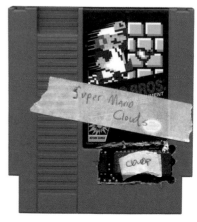

Super Mario Clouds (Game Cartridge), 2002

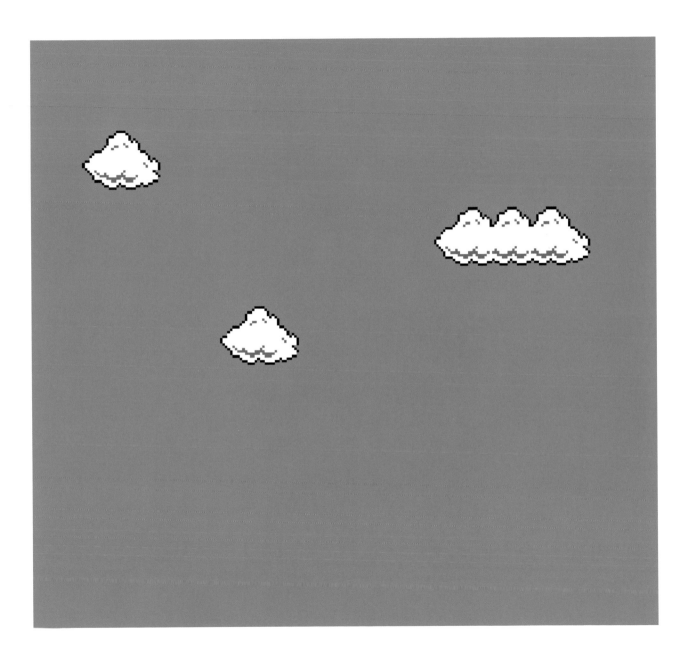

тhe ıntruder

Director, Photoshop, Sound Edit 16
Keywords: Borges, game, network, narrative
http://www.calarts.edu/~bookchin/intruder

Since their appearance in the 1970s, video and computer games have become not only an extremely popular form of entertainment, but also an important cultural form. Yet their often violent nature has made them a persistent subject of debate. *The Intruder* is an interactive Web project that, in Natalie Bookchin's words, "looks like a game but in fact is a critical commentary on computer games and patriarchy".

Bookchin's work is based on a 1966 short story by Jorge Luis Borges, also titled "The Intruder" – a grim tale of prostitution, fraternal jealousy and violence against women in which two brothers fall in love with the same woman, share her and sell her to a brothel. The narrative ends with the woman's murder and the brothers' reconciliation.

Bookchin tells the story through a sequence of ten game-like vignettes, each of which is modelled after an early video game, such as Space Invaders, presenting a loose overview of the early history of the medium. In this project, the video game becomes a symbolic form in which archetypal actions such as catching falling objects, jumping and shooting dramatize themes in Borges' short story. For example, the seventh segment of this project resembles one of the first video games, Pong, in which players control paddles to hit a ball across the screen.

In Bookchin's version, the ball is replaced by a woman's skirted silhouette, photographic images of the nude female body appear on the playing surface, and a female voice reads a passage from the Borges story. The player is implicated in the narrative by hitting the feminine "ball" back and forth, symbolically taking the role of one of the brothers and enacting the cruel exchange of the woman as if she were an object with no agency. By combining literature and games, Bookchin builds a bridge between high art and low culture, calling the distinction between the two into question. This kind of levelling is a common feature of New Media art.

At the same time, Bookchin seems to suggest that, both as a woman and as a contemporary artist, she is herself an intruder in the male-dominated, entertainment-driven world of computer games. The deftness of Bookchin's critique lies in the parallels she

draws between the violence of Borges' misogynist literary narrative and the violence and sexism that are ubiquitous in most games.

In this regard, *The Intruder* is typical of Bookchin's artistic practice, which is often explicitly political. She was a member of ®™ark, an activist art collective that engaged in "tactical media" interventions such as GWbush.com, a Web site that was critical of George W. Bush's 2000 candidacy for President of the United States. Her later, more ambitious project, *Metapet* (2002–2003), is an online game in which players act as corporate managers, controlling genetically modified human employees who have been bred to include a fictional obedience gene found in dogs. In much the same way as *The Intruder* develops a critique of patriarchal violence, *Metapet* criticizes corporate culture.

Metapet, 2002–2003

UMBRELLA.net

Bluetooth modules, DAWN Mobile Ad-Hoc Networking Stack, iPac Pocket PCs with 802.11b and Bluetooth, microcontrollers, sensors, umbrellas, UMBRELLA.net software
Keywords: ad-hoc network, data visualization, participation, wireless
http://www.mee.tcd.ie/~moriwaki/umbrella

Inspired by the sight of multiple umbrellas popping open at random intervals when rain falls on a crowded city street, *UMBRELLA.net* explores the aesthetics of mobile ad-hoc computer networks that form spontaneously between wireless devices. Part engineering research project, part performance, this work features white umbrellas with hand-held computers attached to their shafts.

When a participant in *UMBRELLA.net* opens his or her umbrella, the computer seeks to establish a wireless network connection with other computer-equipped umbrellas in the area. Light-emitting diodes (LEDs) illuminate the umbrella, indicating the connection's status: red when trying to connect and blue when connected. The hand-held computers include a text-messaging application and feature a graphical interface that identifies participants by name. A schematic on-screen diagram of concentric circles indicates each participant's proximity to others in the network.

Although Brucker-Cohen and Moriwaki's interest in network topology stems largely from their extensive technological training (both received Ph.D.s in Engineering at Trinity College in Dublin), they use umbrellas primarily for aesthetic reasons. As they write on the project's Web site: "We believe these transitory networks can add surprise and beauty to our currently fixed communication channels."

This work exemplifies the kind of collaborative effort that is common in New Media art, which often requires a team of technological specialists, similar to a film crew. Brucker-Cohen and Moriwaki worked with a software architect, an electrical engineer, an industrial designer and a hardware engineer. While *UMBRELLA.net* originated in an engineering context, its conceptual charm and spectacular quality indicate the artistic intentions of its makers. The absurd nature of the umbrella's enhanced functionality seems to poke fun at the increasing ubiquity of digital technology in the early 2000s, from robotic vacuum cleaners to microwave ovens that utilize live Web data to determine cooking times.

UMBRELLA.net recalls Christo and Jeanne-Claude's *Umbrella Project* (1984–1991), in which gigantic blue and yellow umbrellas punctuated landscapes in Japan and Southern California. Both projects temporarily transform and aestheticize the public spaces they inhabit by inserting intermittent flashes of colour. In addition, both are fundamentally collaborative in nature. The interactive and spontaneous nature of *UMBRELLA.net* is also reminiscent of the Happenings of the 1960s and '70s, such as those conducted by Allan Kaprow, in which common materials and audience participation blurred the boundaries of art and everyday life.

UMBRELLA.net is an unusual example of data visualization, a genre of new media art that includes John Klima's *Ecosystm* (2001), which represents real-time stock and weather information as animated creatures and digital landscapes, and Martin Wattenberg's *Copernica* (2002), which represents works in NASA's art collection as planets in a navigable galaxy. Unlike its screen-based precedents, *UMBRELLA.net* uses public space as its canvas, painting the cityscape with pulses of colour that create an allegory for data in a real-time system, making visible an emerging network and rendering prosaic technology poetic.

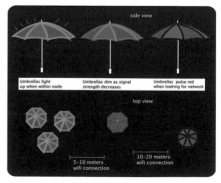

UMBRELLA.net, 2005

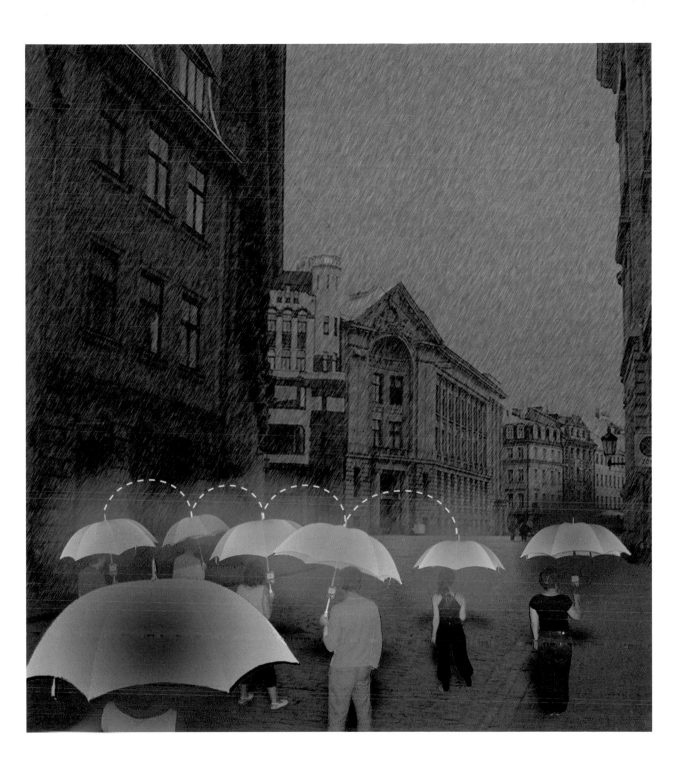

BorderXing Guide

Compass, lightness, map, stealth
Keywords: globalization, migration, network, performance
http://irational.org/cgi-bin/border/xing/list.pl

The fantasy that we live in a global village, a worldwide community connected across geographic distances by an electronic network, is an appealing one. The realities of globalization are far more problematic. Access to technology and to mobility is limited to the privileged, while others are excluded – for political, economic, or social reasons – from networks of communication and transportation. In the post-9/11 age of terrorist attacks and reactionary responses, international travel was tightly controlled. British artists Heath Bunting and Kayle Brandon address these issues in *BorderXing*, an online guide to crossing European borders surreptitiously. The site is addressed primarily – or at least conceptually – to activists, asylum seekers and others who lack the requisite government documents to pass legally from one nation to the next.

Sponsored by the Tate Gallery, London, and Fondation Musée d'Art Moderne Grand-Duc Jean (MUDAM), Luxembourg, the guide is built around a database-driven Web site that contains information about routes between various pairs of countries and documentation of the artists' attempted crossings. Instructions on how to cross specific borders undetected and without a passport are accompanied by hiking maps and lists of necessary tools ("LED torch, Pen, Compass, Notebook…"). Their directions for crossing from Pigna, Italy, to Soarge, France, are typically terse: "Spring and Autumn crossing recommended. Route has been used by refugees before successfully. Take enough food for 10 hour walk."

The artists patrolled the boundaries of the *BorderXing* project by limiting access to some of the Web site's texts to authorized users, thus prompting site visitors to consider how access to information and locations is controlled. In this way, *BorderXing* subverts not only the integrity of national borders, but also our expectations that the Internet is a space of open access for all.

BorderXing is exemplary of the activist nature of much New Media art; Bunting has described himself as an artivist – contracting the words artist and activist to form a neologism that connotes the politically engaged nature of his work. Following in the footsteps of political artists like Hans Haacke, Bunting and Brandon adopt an unadorned, functionalist aesthetic in this project, as if to emphasize that their work is not about decoration or visual pleasure. Yet the beautiful makes a strong showing in *BorderXing* in the form of photographs taken by the artists as they travel illicitly between countries. These often stunning images, traces of the artists' experiments in illegal migration, reveal liminal landscapes of surprising beauty.

In 1999, Bunting collaborated with British artist Rachel Baker on *SuperWeed*, a project that also bridged the virtual and the physical. In this work, Bunting and Baker posted online instructions for a do-it-yourself kit for planting herbicide-resistant seeds. These seeds are intended to be used as a "genetic weapon" against large biotechnology firms that produce genetically modified plants and foods. *SuperWeed*, like *BorderXing*, suggests a metaphorical practice of "hacking" reality by infiltrating powerful institutions and their systems and defying corporate or governmental controls. Like other hacktivist artists, Bunting and his collaborators utilize new media more as means than as ends in themselves.

> **"I do consider myself a combatant. The artist doesn't just gaze. It's not just the perception of reality that is up for grabs, it's reality itself."**
>
> **Heath Bunting**

Brandon

HTML, Java, JavaScript, Perl, PHP, MySQL
Keywords: collage, gender, identity, violence
http://brandon.guggenheim.org

The true story of Teena Brandon, a 21-year-old woman who in 1993 was raped and later killed for passing as a man, fascinated film-going audiences when Hilary Swank portrayed her in "Boys Don't Cry" (1999). A year earlier, the Guggenheim Museum in New York commissioned Taiwanese-American artist Shu Lea Cheang to make *Brandon*, a Web-based art work (the first commissioned by the Guggenheim) that explores Teena Brandon's story in an experimental, non-linear way, conveying the fluidity and ambiguity of gender and identity in contemporary societies.

The first image presented on the *Brandon* Web site is a morphing restroom icon. It transforms in a continuous loop from a baby into a woman, then into a man. This simple animation neatly summarizes Teena Brandon's own experience as a young person who was born a biological woman but later chose to represent herself as a man. The site visitor then clicks through to a web page containing a grid of image fragments: anatomical diagrams of male genitalia, tattoos, pierced bodies, a figure in a man's suit, newspaper headlines, a strap-on dildo. Rolling over these images with the cursor reveals other images, each representing a component in the narrative of Brandon's life and murder. This rudimentary interaction suggests a process of gathering clues to unravel a mystery.

By choosing the Web as her primary medium for this project, Cheang suggests a connection between Brandon's story of gender bending in the physical world and the parallel phenomenon of gender play online, in which people assume online personae that don't correspond to their embodied selves. But Cheang did not limit *Brandon* to the Web. During the year-long project, the site's imagery was displayed on the Video Wall at the now-defunct Guggenheim SoHo in New York. Cheang also organized public forums dealing with the social implications of the digital body, first during the World Wide Video Festival in 1998 at Amsterdam's Theatrum Anatomicum, then in 1999 at Harvard University's Institute for the Arts and Civic Dialogue. Cheang also invited curators, critics and forum participants to add images to the *Brandon* site.

Art critic Liz Kotz describes Cheang's overall body of work, which addresses a variety of timely, media-related topics ranging from music piracy to the pornography industry, as "collaborative ventures, works which cross current political issues with commercial technologies" – characteristics that appear again and again in New Media art practices.

Cheang's use of a Web site to deal with themes of gender and identity in *Brandon* echoes the use of video, a new technology in the 1970s, by such feminist artists as Eleanor Antin and Martha Rosler. Like these artists, Cheang used an emerging form to examine how gender is popularly understood, categorized and defined.

Brandon, 1998

"Every art agency must comply to digital update. only yesterday we were handing in our web work for 'permanent collection' at the museums as long as they can provide the archiving servers. today, we float (in market and travel sense). the dealers will eventually come around and work the scene."

Shu Lea Cheang

Deep ASCII

Asciimator, TTYVideo
Keywords: ASCII, cinema, net.art
http://www.ljudmila.org/~vuk/ascii/film

A seminal figure in the history of New Media art, Slovenian artist Vuk Cosic is widely acknowledged as having coined the term "net.art" in 1995. As New Media artist Alexei Shulgin points out, Cosic' phrase is a Duchampian readymade: Cosic saw the words "net" and "art" conjoined by a dot in a jumbled email message and started using the term to describe Internet-based art. Although the period, or "dot", was eventually dropped, the term quickly caught on.

The title of one of Cosic' best-known projects, *ASCII History of Moving Images*, indicates the artist's interest in the process by which art is historicized. In this work, Cosic converts scenes from classic films and television shows – such as Alfred Hitchcock's "Psycho", the pornographic movie "Deep Throat" (remade as *Deep ASCII*) and the sci-fi series "Star Trek" – into short animations. Cosic uses software to transform each frame of the original into an image in which ASCII characters play the role of pixels or Benday dots to constitute figures, shadows and objects on the screen. Cosic then plays these frames in quick succession, effectively re-animating the original work. First used in 1963, ASCII (American Standard Code for Information Interchange) is a set of numerical equivalents for typed letters and symbols that allows computer users to exchange text between different computer systems.

Cosic was by no means the first to use ASCII characters to make images. When computers lacked graphical capabilities, early computer users produced on-screen drawings by forming lines and shapes out of ASCII letters, numbers and symbols. In the 1990s, it was common for Internet enthusiasts to decorate the ends of their email messages with such ASCII drawings, made either manually or by using software that converts images into ASCII art. By using ASCII to recreate films and television programmes, Cosic extends this rudimentary method of producing images to an absurd limit. In doing so, he creates animations with a retro-futuristic aesthetic.

Cosic was trained as an archaeologist, and his ASCII Cinema exemplifies a media-archaeological approach to art making that is common among New Media artists. Yet Cosic' interest in antiquated technologies is far from academic. His resurrection of ASCII is both a critique of the utilitarian logic that underlies new media development and a celebration of the purposeless.

ASCII History of Moving Images (Psycho), 1999

"[My] works and experiments with moving ASCII… [are] carefully directed at their full uselessness from the viewpoint of everyday high tech and all its consequences. I try to look into the past and continue the upgrading of some marginalized or forgotten technology."

Vuk Cosic

.Xdeep$ascii$www.ljudmila.org

zapatista tactical floodnet

Email, HTML, Java
Keywords: hacktivism, performance, tactical media, theatre
http://www.thing.net/~rdom/ecd/ecd.html

New Media Art often takes hybrid forms, blending art's emphasis on aesthetics and creativity with the imperatives of other disciplines. In 1998, Ricardo Dominguez, Carmin Karasic, Brett Stalbaum and Stefan Wray – collectively known as the Electronic Disturbance Theater (EDT) – blended art and politics by initiating a series of online civil disobedience actions in support of the Zapatista rebels, a revolutionary movement of indigenous people in Chiapas, Mexico, fighting against ongoing governmental oppression. EDT used email and the Web to promote its project to activists around the world, enlisting sympathetic supporters to download and run a Java applet called FloodNet. This applet repeatedly tried to open nonexistent Web pages at targeted sites, such as those of former Mexican President Ernesto Zedillo, former U.S. President Bill Clinton, the Mexican Stock Exchange and Chase Manhattan Bank. Participants in EDT's actions were asked to select words for use in constructing "bad URLs" (Web addresses of pages that don't exist on the targeted server). For example, participants were asked to input the names of Zapatistas killed by the Mexican Army in military attacks on the autonomous village of

Acteal, forcing targeted servers to return an error message each time one of these "bad" URLs was requested. In a deft conceptual gesture, this process inscribed the "bad" URL in the server's error log as a way of symbolically returning the dead to those responsible for their murders. If enough people had run the applet simultaneously, they would have overloaded the server, so that when a regular visitor tried to access the site, pages would have loaded slowly or not at all.

The disabling of a site in this way is known as a "denial of service attack". EDT's actions are analogous to sit-in demonstrations in which protestors block the entrance to a public building. Taking the civil disobedience actions of the American Civil Rights Movement of the 1960s as a model, EDT's members avoid destroying data and use their real names rather than hiding behind aliases. "The idea", according to Dominguez, "is not to destroy or disrupt these Web sites. It's to disturb, in the same way that paper airplanes coming through your window are going to annoy you." Dominguez alludes here to the symbolic Zapatista airforce, composed entirely of paper planes.

EDT's work exemplifies the use of "tactical media", or the deployment of low-cost communication tools to protest against government and corporate institutions in a wide-reaching, high-impact manner. "We don't have massive PR firms or the ears of The New York Times. So we have to make gestures that are attractive to the media", Dominguez says. Trained as an actor, Dominguez led agit-prop theatre productions in the 1980s as a member of ACT-UP, the New York-based AIDS activist organization. He then worked for several years with Critical Art Ensemble, a group that published several books on media and politics, including "Electronic Civil Disobedience & Other Unpopular Ideas", before forming EDT in 1997.

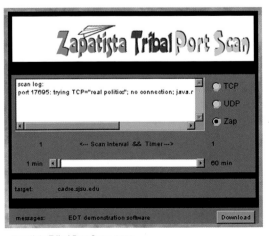

Zapatista Tribal Port Scan, 2001

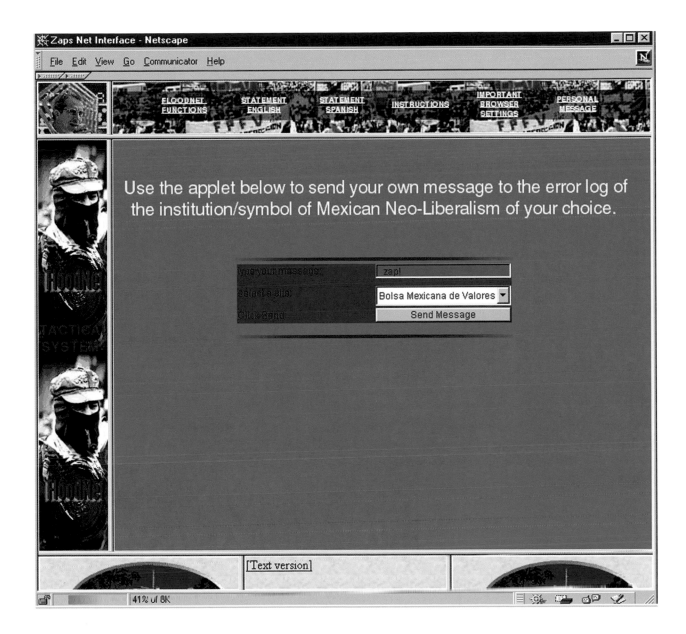

etoy.SHARE

Certificate financing/representing Toywar
3DS Max, Elm, FTP, SSH Daemon, Lambda print, Mutt, MySQL, Netscape, PGP, Photoshop, PHP, Sendmail
Keywords: collaboration, corporation, hacktivism
http://www.etoy.com

In the mid-1990s, the Internet was seen by many to be a great leveller. Because the costs of publishing a Web site were so low, a band of artists could have as visible and far-reaching a presence as a large corporation. Many New Media artists and artist groups took advantage of this aspect of the Web, choosing to represent themselves online (and offline) as corporations or corporate-sounding entities, complete with slick logos and slogans. Among the first to take this approach was a group of European artists who, in 1994, were inspired by corporations with strong brand identities, formed a Swiss corporation called Etoy and, in 1995, set up a Web site at http://www.etoy.com.

In its mission statement, Etoy describes itself as a "corporate sculpture" that "crosses and blurs the frontiers between art, identity, nations, fashion, politics, technology, social engineering, music, power and business to create massive impact on global markets and digital culture. Etoy goes where common companies and individuals can't afford or risk to go." Following the model of many business ventures, Etoy raised funds for its projects and

issued stock to its shareholders, with stock certificates serving as art objects. Somewhere between a subtle critique and a serious proponent of corporate culture, Etoy combines online projects with performative interventions and ironic actions.

In 1999, at the height of the "dot com" boom, a well-funded online toy merchant called eToys received a complaint from a customer who had mistakenly visited the Etoy Web site and encountered profanities. eToys accused Etoy of trademark infringement, despite the fact that the artist group had registered its Web address two years earlier than the online toy store had registered its own. eToys offered Etoy 516,000 U.S. Dollars to surrender its name, but the artists rejected eToys' monetary offer, prompting the Silicon Valley startup to sue. Rather than capitulating to this spurious litigation, Etoy launched a grassroots counter-offensive, a multifaceted Net art project titled *Toywar*.

Using the Internet as its battlefield, Etoy created an online game in which sympathetic members of the global New Media art community earned points by attacking eToys, with the goal of driving down eToys' stock price. The game tracked participants and their real-world activities, which included criticizing eToys in online chat rooms and investor forums, corrupting eToys' server logs with false information and creating anti-eToys Web sites. Popular bands donated MP3s for the game's soundtrack in support of Etoy's cause.

The saga ended in late January 2000, when eToys announced it was dropping the lawsuit. Between November 1999 and February 2000, 1,798 people came to Etoy's defence by participating in *Toywar*. During this same period, the aggregate value of eToys' stock declined by some 4.5 billion U.S. Dollars. Although it is unclear to what extent the collapse in eToys' market capitalization was the result of *Toywar*, and to what extent it was due to other economic factors, Etoy nonetheless claims that *Toywar* was "the most expensive performance in art history".

etoy.SHARE, 2000

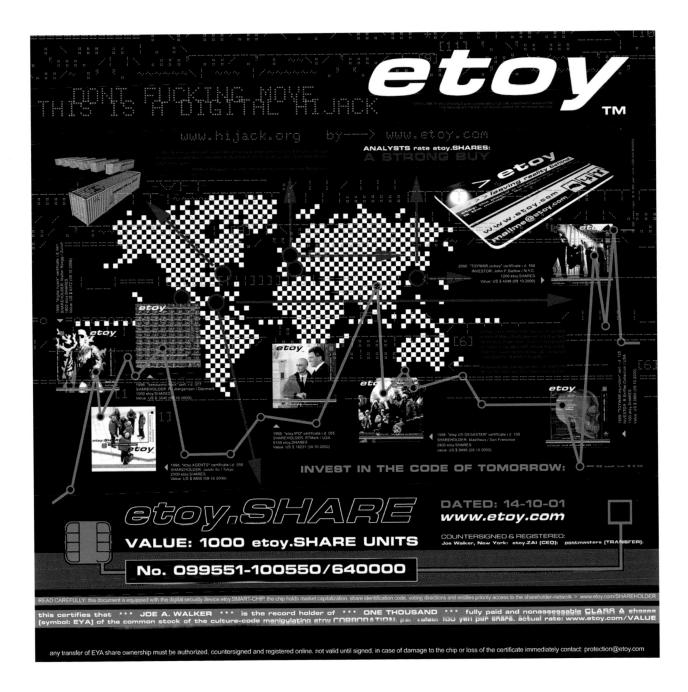

[domestic]

Data projector, graphics card, joystick, PC, Unreal Tournament 2003
Keywords: feminist, game, narrative
http://www.maryflanagan.com/domestic

Mary Flanagan is one of many New Media artists who work with computer games both as a medium and as a subject of investigation. *[domestic]* is a computer game based on a commercially-produced game engine called Unreal Tournament, a popular "first person shooter" in which players enter an immersive three-dimensional environment and blast away enemies as they explore a labyrinthine warren of rooms. *[domestic]* could be called a détournement of Unreal Tournament, a redirection of the popular game for artistic purposes. Whereas Unreal Tournament conveys a narrative of violent conquest typical of many popular games, Flanagan uses the game engine to create a home-like environment for the exploration of childhood memories and feelings. Flanagan populates *[domestic]* with photographic images and fragments of text that suggest internal turmoil rather than outward aggression, replacing physical battles and demons with psychological ones.

According to Flanagan, *[domestic]* does not directly critique violent shooter-style games or the interaction players have within them. Instead, it seeks to make games political and to question the assumptions we bring to games. Flanagan asks, "Can 'high tech' game spaces, often violent, cold, or impersonal, be subverted to create the inverse experience: an affective game that personalizes the space and therefore politicizes it? Can navigation in a 3D game operate as a means of challenging or 'un-playing' the conventional workings of shooter games?"

[domestic] is based on an event that took place when the artist was seven years old, in her home town in rural Wisconsin. As she walked down a wooded path on her way home from church, she noticed smoke billowing from the windows of her familiy home and began to run frantically toward it, knowing her father was inside. Flanagan recreates this traumatic early memory in the architecture of the game space and the images and texts that cover its walls. The task of the game is to enter the house and put out the fire in the burning rooms.

[domestic] functions as an installation within the virtual environment of the game engine; Flanagan appropriates Unreal Tournament much as a conventional installation artist might approach the space of a gallery and transform it into a three-dimensional environment-as-art work. In the case of *[domestic]*, Flanagan covers the walls of the cavernous space with images of woods, the family house and photographs culled from family photo albums.

Like much of Flanagan's work, *[domestic]* has a distinct feminist logic. In her work as a multi-media producer and educator, she developed one of the first interactive Web games for girls, *The Adventures of Josie True*, and worked on a collaborative educational project that helped teach young girls how to program computers via a networked game environment. In *[domestic]*, Flanagan replaces a narrative of external, physical conflict with one of internal, emotional exploration, suggesting that video games aren't just for boys (and girls) who want to play war, but also for girls (and boys) who want to play house.

[domestic], 2003

тelegarden

Custom planter, industrial robot arm (Adept 1), irrigation, video cameras, World Wide Web interface
Keywords: installation, telepresence, participation
http://queue.ieor.berkeley.edu/~goldberg/garden/telegarden

How do we trust what we see online and know it is authentic? *Telegarden*, which first went online in 1995, raises questions related to what the artist calls "telepistemology", or the study of the nature of knowledge gained through remote, mediated sources such as the Internet. This work promises gardeners from around the world a chance to tend living plants by watering and feeding them via the Web, using an industrial robotic arm, similar to those used in auto factories.

Ken Goldberg, an artist and an engineering professor at the University of California, Berkeley, provokes us to consider whether the garden really exists. We wonder whether we can truly trust that users' actions have actually contributed to the growth of the blossoming and verdant plants represented on the *Telegarden* Web site, or whether the entire art work is staged. Although the robot and the garden are both real and are in fact controlled by users via the Internet, Goldberg asserts that "media technology generally facilitates the suspension of disbelief. I'm trying to facilitate the resumption of disbelief."

The physical elements of *Telegarden* were installed at the Ars Electronica Center in Linz, Austria, bridging the gap between the virtual space of Net art and the physical space of the gallery, much as Nam June Paik, Bruce Nauman and Gary Hill extended video art from the realm of the screen into the three-dimensions of sculpture. Goldberg's installation features a robotic arm centred on a white, table-like plinth, surrounded by a small, neat garden that circles the mechanical device. The garden includes a variety of colourful flowers planted in soil, an organic contrast to the high-tech design of the robot. Online users register as community members, log onto the *Telegarden* Web site and take care of the plants from afar. In its first year online, 9,000 members signed up to participate in this exercise in collective online gardening. As media theorist Peter Lunenfeld writes: "In linking their garden to the World Wide Web and creating an intuitive interface for the control of the arm and camera, the artists transformed what most would consider a fit of over-engineering into a subtle rumination on the nature of the Commons."

In *Demonstrate* (2004), Goldberg continues to explore how the Internet and Webcams influence the ways we observe and interact with the world around us. This piece consists of a state-of-the-art telerobotic surveillance camera situated above Sproul Plaza at U.C. Berkeley, a site of student anti-war demonstrations and a launching pad of the Free Speech Movement of the 1960s. Using an easy-to-navigate interface, visitors to the *Demonstrate* Web site can focus on and zoom in on unwitting students, faculty members and other passersby, as well as post text related to the Webcam images. Created in honour of the 40th anniversary of the Free Speech Movement, *Demonstrate* raises questions about freedom and privacy in public spaces in an age of pervasive surveillance, when governments and corporations routinely utilize technologies to capture our images without consent.

Demonstrate, 2004

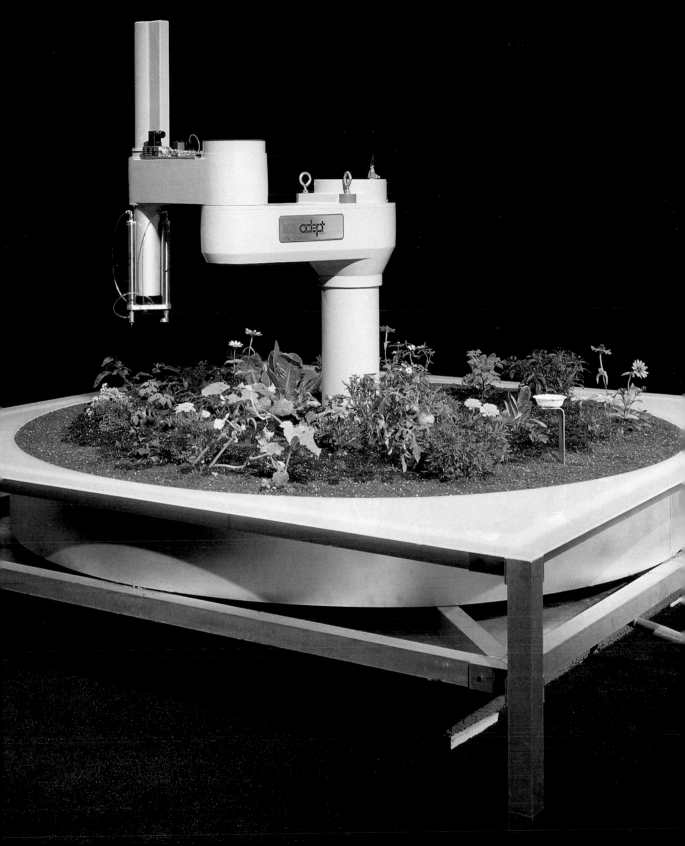

A-trees

CO_2 sensor, desktop plant, simulated Paradox clones
Keywords: artificial life data visualization, environment
http://onetrees.org/atrees/index.html

Is the term "artificial life" an oxymoron? Natalie Jeremijenko, an artist trained in science and engineering, creates works that force us to examine the problematic consequences of digital and other technologies, such as cloning, robotics and software. *A-trees*, for example, allows us to witness the growth of a simulated tree on a computer desktop, as if it were an actual plant in soil. The tree is programmed to change gradually in size, thanks to a self-replicating growth algorithm. The tree's growth rate isn't determined solely by Jeremijenko's programming, however. Every upward spurt reflects the actual level of carbon dioxide in the air in the micro-environment surrounding the computer, measured by a

real-time carbon-dioxide metre. More than mere renditions of a living tree, Jeremijenko's *A-trees* serve as aestheticized monitors of actual air quality and, by extension, global warming. They call into question the fate of real trees in a world whose environment is increasingly impacted on by humans, as if to suggest that one day the only trees left will be digital ones. The work's title alludes to artificial life, commonly known as "a-life". If *A-trees* grow and die in response to their environment, are they in fact alive? Jeremijenko cleverly bridges the real and the virtual, both as a technical feat and as a conceptual gesture, encouraging us to question our understanding of life and how we might work not only to recreate it digitally, but also to preserve it.

Jeremijenko's *Stump* (1999) involves what the artist describes as a "printer queue virus" that calculates how many pieces of paper a printer has consumed. When the printer uses the rough equivalent of one medium-sized tree's worth of paper, it automatically spits out a printed image of a

Stump, 1999

ringed cross-section of a tree trunk. Eventually, a tree – or at least a tree stump – could be reconstructed by stacking these paper rings. Like *A-trees*, *Stump* encourages us to develop a personal relationship to environmental destruction. In 2000, "Mute", a London New Media art magazine, published both *Stump* and a version of *A-trees* on a CD-ROM and linked the two to a public art project, *One Tree*, which involved the planting of 1,000 clones of a single tree around San Francisco.

Jeremijenko's first arboreal art work was *Tree Logic* (1999), a public sculpture at MASS MoCA in which six live trees are permanently suspended upside down, inverting their natural orientation and challenging our notions of what is natural. Jeremijenko's tree projects bring to mind works by Robert Smithson, who often used trees as elements of art works that re-examined the natural landscape. Smithson's 1972 declaration, "I aim for an art that takes into account the direct effect of the elements as they exist from day to day apart from representation", could easily be applied to Jeremijenko's work, which investigates the relationship between technology and the natural world.

> "The problem with technology is that in general it's developed by people with resources for the benefit of those with resources. It's a profoundly conservative social force. Another interesting aspect is that it's too complex to control. Technology bites back, but its unintended consequences present an opportunity to redress the environmental crisis we're facing."
>
> Natalie Jeremijenko

wwwwwwwww.jodi.org

HTML.403
Keywords: Net art, conceptual, glitch
http://wwwwwwww.jodi.org

Like many Net art projects, *jodi.org* has gone through several incarnations. When it first appeared online in 1993, its home page (now available at wwwwwwww.jodi.org) was a screen of garbled green text – an unintelligible jumble of punctuation marks and numerals blinking on and off on a black screen. At first glance, the *jodi.org* home page looked like an error, as if the person who created the page were just learning how to use HTML (Hypertext Markup Language) and hadn't quite figured it out, or perhaps seemed to be the result of some kind of glitch in the browser software. But if site visitors knew to view the page's source code (a HTML document that tells the browser what to display), they were in for a surprise: between correctly constructed HTML tags, the artists had inserted a diagram, drawn in slashes and dots, of a hydrogen bomb, as if to explode expectations about the Web as a medium.

wwwwwwww.jodi.org (%Transfer | HQX)

Clicking past the home page led to screen upon screen of digital detritus: fragments of pixellated images, blinking text, animations gone awry. Upon exploring the rest of the site, it quickly became clear that the first page of scrambled text was not an error, but rather an intentional display of one of the Internet's fundamental aesthetic properties: the glitch.

Jodi.org can be seen as a formalist investigation of the intrinsic characteristics of Internet as a medium. But *jodi.org* operates on a conceptual level as well. In addition to experiments in glitch aesthetics, there is also a bomb in the source code – a hidden message to those in the know. Artist Sol LeWitt described Conceptual art as work in which "all planning and decisions are made beforehand and the execution is a perfunctory affair. The idea becomes the machine that makes the art." Joan Heemskerk and Dirk Paesmans, the artists behind *jodi.org*, did not type in their home page's slashes, colons, brackets and numerals by hand – their idea was to put an image of a bomb in the source code of a Web page, so that the browser would try to interpret it as a HTML file, blowing it up on the screen. This idea functions as a machine that makes the work anew each time someone loads the page.

Jodi.org became the archetypal Net art project, and the artists themselves became celebrities within the global Net art scene. Heemskerk and Paesmans were among the first artists to turn their attention to games, creating modified versions of popular titles such as Castle Wolfenstein, Quake and Jet Set Willy. Like Jodi's online work, their modifications of games enact a deconstruction of the medium, playfully exploiting bugs to produce disconcerting experiences of technology.

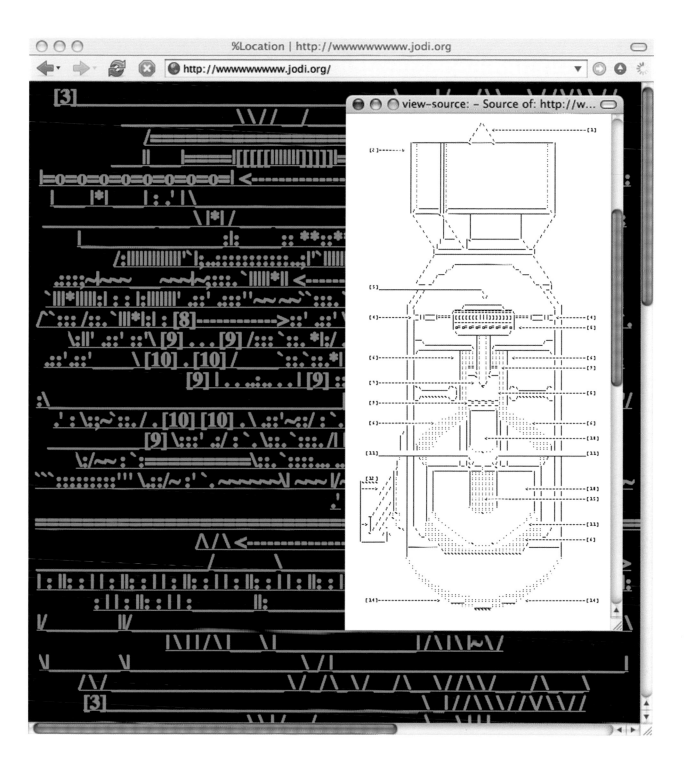

pedestrian

3DS Max, AfterEffects, Character Studio, motion analysis equipment, Premiere, Quicktime Pro, Tree Professional 5
Keywords: animation, intervention, motion-capture
http://www.openendedgroup.com/artworks/pedestrian/pedestrian.htm

We experience a brief moment of vertigo when looking at Paul Kaiser and Shelley Eshkar's *Pedestrian*, a New Media art project that requires us to peer down, as if we are hovering high above, at tiny human figures projected on the sidewalk or gallery floor. These animated Lilliputians move with uncanny verisimilitude over the streets and plazas of a trompe-l'œil city that has been rendered digitally with near-photographic realism. The figures move in and out of virtual buildings, open umbrellas to avoid synthesized raindrops and dodge one another in crowds. Occasionally, they seem to move in formations that suggest flocks of birds or to trace complex patterns on the ground as if performing choreographed routines. Yet there is no linear progression of events, or singular narrative.

Kaiser and Eshkar used motion-capture technology to imbue their miniature characters with realistic movement. They asked eight people to wear form-fitting suits on which reflectors were attached at strategic locations to articulate the motion of their body parts. Infrared cameras recorded the performers' movements as data that were then manipulated, recombined and mapped onto three-dimensional models of human figures. These models are covered with digital renditions of skin, hair and clothing to represent a range of urban types, from men in business suits to school children. Kaiser and Eshkar's use of motion-capture suits recalls the 19th-century experiments of French physiologist Etienne-Jules Marey, who invented a system for placing lights on various parts of a subject's body to track movements on camera as a way of analyzing the mechanics of human action.

Pedestrian was inspired in part by "Crowds and Power" (1960), a book by Nobel-Prize-winning author Elias Canetti that examines follow-the-leader behaviour and the pack mentality of crowds. In addition, the artists drew on urban images by the modernist photographers Aleksandr Rodchenko, Gary Winogrand and Henri Cartier-Bresson. *Pedestrian* includes a soundtrack composed by computer musician Terence Pender, featuring a soundscape of urban noises like a gate opening or a discarded soda-can bouncing down the street. Sometimes these sounds aurally illustrate the animated action; at other times, the soundtrack evokes a world outside the immediate frame. For example, in one scene, we hear an ambulance siren in the distance as an inline skater rolls into view.

Pedestrian positions us as omniscient observers, panning over the city as if from a police helicopter. Removed from the figures below, we witness the movements of the city's inhabitants without the ability to interact with them. At the same time, because these figures occupy the actual physical space in which we stand, we are somehow implicated in their lives. *Pedestrian* has been installed at many sites around the world, including the Studio Museum in Harlem, the ZKM Center for Art and Media in Karlsruhe and the InterCommunication Center in Tokyo. Viewers often call out to the figures or walk among them, casting shadows that invade their world.

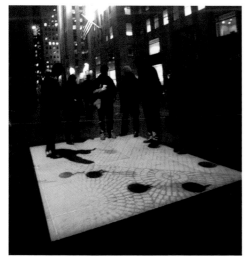

Pedestrian, 2001–2002

Glasbead

C++/DirectSound, Sense8 WorldUp, Visual Basic
Keywords: 3D, collaboration, interface, music, tool
http://www.glasbead.com

After graduating from the State University of New York at Purchase with a Bachelor of Fine Arts in photography, John Klima worked for several years as a software programmer. Freelance jobs afforded him a flexible schedule, allowing him to pursue his artistic practice while paying the rent in New York. But these day jobs also helped him develop skills that he put to use when creating his New Media art works. A stint at Microsoft, the company behind the ubiquitous Windows operating system, got him thinking about alternatives to the desktop metaphor for organizing files and applications on a computer. Klima also had a long-standing interest in three-dimensional interfaces. These trains of thought led him to create *Glasbead*, a psychedelic online art work that enables up to 20 simultaneous participants to make music collaboratively via a colourful three-dimensional interface – a translucent blue orb, rendered in three dimensions. The orb contains multiple stems, each radiating from the orb's centre like pistils from a flower. There are two kinds of stems: "bells" and "hammers", each of which can be flung around the sphere with the drag of a mouse. Participants compose music alone or with others by uploading sound files to the bell stems, controlling volume and pitch by manipulating purple rings that surround the stems. When a hammer stem strikes a bell stem, the music file plays. The entire spherical structure can be spun by clicking and dragging a ball at the centre of the orb.

Glasbead exemplifies the convergent nature of New Media art. Although Klima was trained as a visual artist, his programming skills enabled him to cross disciplinary boundaries to produce a tool for making music. Yet this tool is highly aestheticized and rich in visual detail. Its title and conceptual foundations are indebted to literature. Klima was inspired in part by Hermann Hesse's final novel, "The Glass Bead Game", for which Hesse won the Nobel Prize for Literature in 1946. The novel, which is set in the 23rd century, centres around a fictional game in which cultural values are played like notes on an organ, requiring players to synthesize their knowledge of both philosophy and aesthetics. Widely discussed by technologists and futurists, Hesse's "Glass Bead Game" has been described as a prescient metaphor for the Internet. Despite its obvious references to the game in Hesse's novel, Klima's *Glasbead* is less a realization of Hesse's vision than a hallucinatory spin-off in which sounds take the place of ideas, a futuristic musical instrument that enables collaborative play.

> **"I simply refuse to make work that compensates for the user being an idiot. In 'Glasbead', if you load it up with stupid sounds and spazz out on the interface, it will sound stupid. If you consider what you load and consider what you fling, it sounds really nice."**
>
> John Klima

Thebaid (after Starnina), 2005

minds of concern:: Breaking News

Flash, Nessus Attack Scripting Language, MySQL, Pd, Python
Keywords: hacking, hacktivism, installation
http://unitedwehack.ath.cx

In May 2002, the artist group Knowbotic Research (Yvonne Wilhelm, Christian Huebler and Alexander Tuchacek), working with Peter Sandbichler, presented *Minds of Concern::Breaking News* as part of a group exhibition titled "Open_Source_Art_Hack" at the New Museum of Contemporary Art in New York.

Minds of Concern::Breaking News consisted of a Web site and a physical installation in the museum's media lounge. The Web site featured port-scanning software that searched for security vulnerabilities on the Internet servers of selected non-governmental organizations (NGOs) and media activists. Visitors to the *Minds of Concern* Web site initiated port scans via a colourful slot machine interface called the "Public Domain Scanner" to determine the vulnerability of targeted servers to hacking attacks. Port scanning is legal in the United States, but it is often prohibited by Internet service providers because it can help hackers figure out how to gain unauthorized access to servers, much as driving down the street looking for open windows might be a thief's prelude to breaking into homes. In *Minds of Concern*, the results of the port scan were displayed anonymously in "newsticker style" on the Web site and in the gallery installation, which included flashing lights, data projections and sculptural constructions made of plastic food boxes and trash cans.

While Knowbotic Research's focus on exposing the vulnerability of NGOs' Web sites might seem surprising – most politically charged Net art targets corporations or governmental institutions – the project's goal, according to the artists, was to "pinpoint the dilemma of NGOs and media artists having to protect an independent and progressive political and social practice through security measures which are constantly being tried, tested and attacked with ever new invasive tools".

As if to illustrate the fragility of media activism in an age of increasingly Orwellian control of online spaces, *Minds of Concern* was taken offline by the Museum after its Internet Service Provider (ISP) threatened to shut down its Internet access. Although Knowbotic Research's project did no harm to the servers it accessed (the artists disabled particularly invasive features of the software prior to the exhibition), the art work did not comply with the ISP's acceptable use policy. Because the port-scanning programme used in *Minds of Concern* was disabled, the accompanying display of lights and sounds no longer flashed within the installation. While no American Internet service providers immediately agreed to host *Minds of Concern* during the run of the "Open_Source_Art_Hack" exhibition, a German provider eventually agreed to host the art work after the New Museum exhibition had closed. Given that Knowbotic Research's intent was to stimulate debate about the conflict between security and the public domain, the action taken to defang *Minds of Concern* offered a vivid example of life imitating art.

> **"new ways of public acting must not fall into the trap of the worn dichotomy of private and public but instead open new possibilities of public agency for domains of the commons."**
>
> **Knowbotic Research**

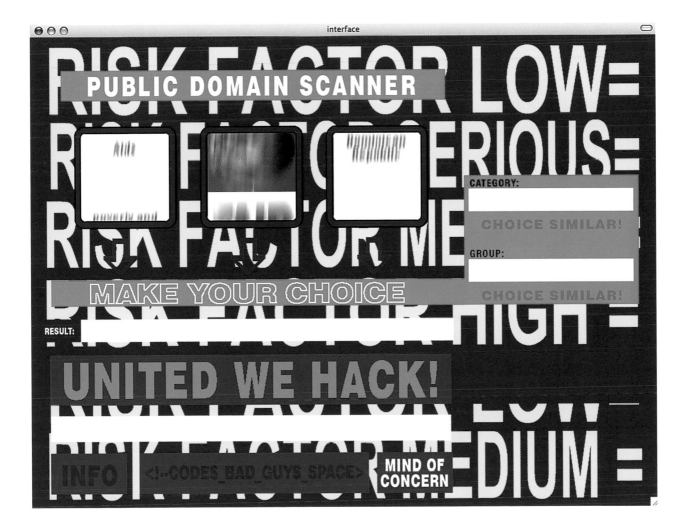

GOLAN LEVIN WITH SCOTT GIBBONS, GREGORY SHAKAR AND YASMIN SOHRAWARDY

Dialtones: A Telesymphony

ASP, Base Transceiver Stations, E1 ISDN lines, MySQL, Mobile Switching Centers, OpenGL, RTTTL (RingTone Text Transmission Language), SMS, UDP
Keywords: mobile, music, performance, wireless
http://www.flong.com/telesymphony

In the decade between 1994 and 2004, mobile phones became so omnipresent that a new etiquette appeared in movie theatres, concert halls and other performance spaces: the ritual silencing of these ubiquitous devices. Golan Levin and his collaborators Scott Gibbons, Gregory Shakar and Yasmin Sohrawardy invert this social practice in *Dialtones: A Telesymphony*, a musical performance played on the audience's mobile phones, whose rings in public spaces are otherwise considered noise pollution.

Dialtones was first performed in 2001 at the Ars Electronica festival in Linz, Austria. Two hundred audience members joined the telephonic orchestra by registering their mobile phone numbers at secure Web kiosks at the concert site. The artists assigned these participants specific seats and downloaded onto their phones special ringtones for the performance.

By determining the exact location and tone of each mobile phone in advance, Levin and his team were able to produce diatonic chord progressions, spatially distributed melodies and roving clusters of sound. On-stage performers acted as orchestral conductors, utilizing a "software instrument" to call participants at specific intervals. The composition of ringtone sounds, accompanied by synchronized projections, lasted about thirty minutes and created sonic effects unique to this new medium. The music reached a crescendo when all two hundred mobile phones rang within a span of four seconds. *Dialtones* was also performed a year later at Arteplage Mobile de Jura in Switzerland.

"If our global communications network can be thought of as a single communal organism, then the goal of *Dialtones* is to indelibly transform the way we hear and understand the twittering of this monumental, multicellular being", Levin explains. "By placing every participant at the center of a massive cluster of distributed speakers, *Dialtones* makes the ether of cellular space viscerally perceptible." *Dialtones* calls attention to the new kinds of social relations that have arisen around mobile phones and in doing so transforms this quotidian technology into a platform for artistic experiment.

Levin studied drawing, painting and musical composition before teaching himself how to program computers in 1996. *Dialtones* builds on the legacy of John Cage, who used sounds from everyday life in his music, and whose work inspired generations of musicians and artists. However, unlike Cage, who reacted to the rigidity of 20th-century musical compositions by applying chance and variability to his work, Levin and his collaborators attempt to infuse the unpredictable, often incompatible international cellphone network with a sense of symphonic order.

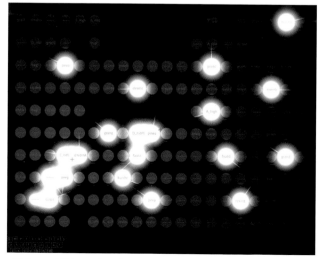

Dialtones: A Telesymphony (screenshot of GUI for triggering phones), 2001

My Boyfriend came Back from the war

GIF animations, GIF images, HTML
Keywords: cinema, hypertext, narrative
http://www.teleportacia.org/war/war.html

One indicator of the historical significance of Olia Lialina's 1996 Net art project, *My Boyfriend Came Back From the War (MBCBFTW)*, is the numerous times it has been appropriated and remixed by other New Media artists. On her Web site, Lialina maintains an extensive list of these appropriations that includes versions in Flash, Real Audio, VRML, the Castle Wolfenstein game engine (Mac and PC), PowerPoint and video. There is even a blog version and a version in gouache on paper. But what is it that makes this particular work so influential? Perhaps it resonates with other artists because it is among the earliest works of New Media art to produce the kind of compelling and emotionally powerful experience that we have come to expect from older, more established media, particularly film.

MBCBFTW tells the story of two lovers who reunite after an unspecified military conflict. Fragments of disjunctive dialogue convey the profound difficulty the couple has reconnecting. The female protagonist confesses that she had an affair with a neighbour while her significant other was away fighting for their country. The returned soldier proposes marriage. The non-linear narrative unfolds through grainy black-and-white images and bits of text in white on a black background. Clicking on a linked text or image splits the frame into smaller frames, each revealing a new text or image. The narrative splits as well, unravelling into multiple threads. This flow produces an effect similar to a cinematic montage in which separate but simultaneous actions are edited together to produce temporal and spatial juxtapositions. Eventually, the images and texts stop appearing, leaving most of the screen a mosaic of empty black frames.

MBCBFTW's cinematic quality was not inadvertent: Lialina studied film criticism at Moscow State University and organized Cine Fantom, an experimental cinema club in Moscow. Lialina approached the Internet as she would film, an older medium with which she was intimately familiar, producing a Net art project that recalls the grainy black-and-white imagery and intertitles of an early silent movie. *MBCBFTW* illustrates media theorist Marshall McLuhan's assertion that each new medium is understood in terms of those that precede it. Much as films are sometimes called "moving pictures", Lialina calls *MBCBFTW* a "netfilm".

My Boyfriend Came Back From the War is also an example of hypertext, a literary genre that predated Net art by three decades. First conceived by Ted Nelson in the 1960s, hypertext is a form of writing in which documents are linked together to form a non-linear structure that can be navigated interactively by the reader. Lialina's use of nested HTML frames to spawn parallel story lines represents an important contribution to the history of hypertext as it made the transition from offline systems to the Web.

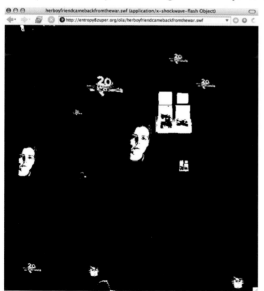

Auriea Harvey/Michael Samyn, MBCBFTW (Flash Remix), 2000

http://www.teleportacia.org/war/wara

vectorial Elevation

Robotic 7 kW xenon searchlights, webcams, TCP/IP to DMX converter, Java 3D interface, GPS tracker, Linux, email servers
Keywords: public, spectacle, telepresence
http://www.alzado.net

At the turn of the 21st century, the doomsday scenarios that many anticipated – from Biblical Armageddon to Y2K computer malfunctions – failed to materialize. Mexican-born artist Rafael Lozano-Hemmer satisfied an otherwise unquenched thirst for spectacle by placing 18 robotic searchlights around Mexico City's Zócalo, the world's third largest urban square. In *Vectorial Elevation*, an ambitious New Media art project that was first presented in Mexico City to celebrate the new millennium, participants used a Web-based interface to control the searchlights, choreographing patterns on the night sky and the urban landscape. Lozano-Hemmer calls this type of performance "Relational Architecture", which he defines as "the technological actualization of buildings with alien memory". In other words, laypeople and passersby (who possess the "alien" memories of outsiders) can construct new meanings for edifices, usually via technological tools – such as Internet software and robotic lights. Lozano-Hemmer cites the work of Thomas Wilfred, an artist who, in the 1920s, was an early innovator in light-based art works, as an influence. Wilfred invented a keyboard-like machine called the "Clavi-lux" to project light onto New York City skyscrapers.

When a participant's design for *Vectorial Elevation* reached the head of the Web queue, it was beamed into the sky, visible to crowds on the ground in Mexico City and, via Web cameras, to a large online audience. The searchlights were connected by data cables and calibrated by Global Positioning System trackers. More than 800,000 people from 89 countries visited the Web site in a two-week period. The light show they produced was visible within a 20-kilometer radius. When each design was executed, its maker received an e-mail linking to an automatically-generated personal Web page displaying both photographic images and virtual renditions of the performance. Each page also featured participants' uncensored texts, ranging from dedications to political manifestos.

The project's aesthetic effect evokes that of *Tribute in Light* (2002), a temporary public art memorial to the victims of 9/11, by Julian LaVerdiere and Paul Myoda, who utilized vertical beams supplied by 44 searchlights placed at Ground Zero in New York to project vertical beams into the night sky above the World Trade Center's destroyed Twin Towers. Like *Tribute in Light*, *Vectorial Elevation* was hard to ignore because of its giant scale and inescapable presence. But Lozano-Hemmer describes his project as an "anti-monument" that serves primarily as a platform for public self-expression. Lozano-Hemmer installed later incarnations of *Vectorial Elevation* in Spain, France and Ireland, each time drawing large audiences both in the streets and online.

New Media artists often make use of technologies in order to critique them. Although Lozano-Hemmer uses technologies that suggest panoptic regimes of control, *Vectorial Elevation* is primarily a celebration of the potential these technologies have to produce a new kind of participatory spectacle.

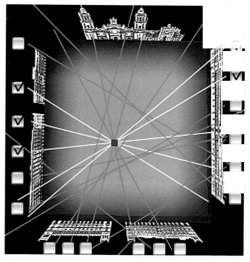

Vectorial Elevation, 1999

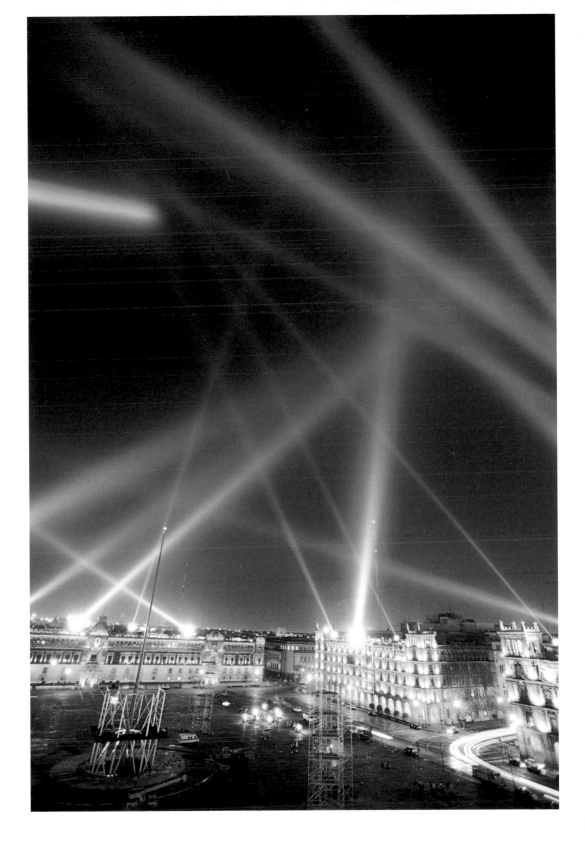

Horror chase

Lingo, PC with video distribution subsystem, Quicktime
Keywords: cinema, database, installation, remix, time
http://www.mccoyspace.com

Horror Chase, an "electronic sculpture" by Jennifer and Kevin McCoy, is an elaborate digital remake of a scene from "Evil Dead II" (1987), the highly stylized camp/cult horror movie directed by Sam Raimi. Rather than sampling and remixing the original work, as they did in *201: A Space Algorithm* (2001) and *Every Anvil* (2001), the husband-and-wife team recreated a scene in which a man is pursued through a labyrinthine interior by building a 1000-square-foot movie set where they shot the scene in 16mm film. The McCoys then digitized the footage and played it back on a computer using home-brewed software that switches at random intervals from forward to reverse playback, producing a Sisyphean, never-the-same-way-twice sequence in which the desperate man runs toward, then away from, then toward his attacker. Why this particular scene? "We were thinking about Mannerism", Jennifer McCoy explains, "in the sense of a highly (over)developed form… We chose the height of the horror genre, which is the chase, the epitome of horror, and then used software to hang up the narrative."

Horror Chase, 2002

The McCoys included several takes of each shot, and each is given equal weight by their home-grown editing algorithm. According to Jennifer McCoy, "The piece's variability comes from subtle differences in the performance of the actor and in the lens used (some shots are much wider and reveal the fakeness of the set) and in their relationships to the direction and speed of the playback." As in several other projects by the McCoys, the high-tech hardware is packed in a hard-shelled black suitcase as if ready to travel the global New Media festival circuit or be transported to various international contemporary art galleries and biennial exhibitions. The video can be displayed on a screen embedded in the suitcase, or projected on a wall.

The duo has been collaborating since 1996, and movies and television are increasingly central to their artistic practice. *Horror Chase* marks a departure from the McCoys' earlier works, which deconstruct films and television shows by sampling them digitally, placing their constituent parts in databases and reconstructing the original works in new ways. These earlier projects exemplify New Media theorist Lev Manovich's concept of "database aesthetics". According to Manovich, "Many New Media objects do not tell stories; they do not have a beginning or end… Instead, they are collections of individual items, with every item possessing the same significance as any other."

The McCoys' *Every Shot/Every Episode* (2000), for example, applies database aesthetics to the 1970s television show "Starsky and Hutch". After digitally encoding 20 episodes of the series, the McCoys broke it down into separate scenes, then used a database to sort the scenes according to categories like "Every Ominous Music" and "Every Racial Stereotype". By reorganizing this television series according to their own idiosyncratic logic, the McCoys disrupt the narrative logic of each episode to reveal the show's aesthetic underpinnings.

mouchette.org

HTML, Flash, Java, PHP, MySQL
Keywords: adolescence, identity, interaction
http://mouchette.org

Art history is replete with examples of artistic alter egos, from Marcel Duchamp's Rrose Selavy to Luther Blissett, a British soccer star whose name was assumed in the mid-1990s by numerous Net artists and activists when posting to email lists and online discussion forums. In 1996, a Web site that purports to be the work of an adolescent girl appeared at *http://mouchette.org*. Visitors to the site are greeted with a lurid close-up of a flower, its petals crawling with ants and flies, accompanied by a portrait of a sad-looking girl and the following text: "My name is Mouchette/I live in Amsterdam/I am nearly 13 years old/I am an artist."

Some of the site's content has a deceptively innocent quality. For example, clicking on the word "artist" on the home page leads to a page with the following text: "An artist? Yes. Here is a tip: I heard that the only way to become an artist is to say you are one. And then you can call 'art' everything you make… Easy, he?" Other sections are more grotesque (images of raw meat) or sexually suggestive (a tongue licking the screen). Many pages feature interactive Web forms, including multiple-choice questions that trigger delayed-reaction emails — days or weeks later, visitors receive unexpected, often flirtatious emails from Mouchette. There is also a listing of members of Mouchette's international fan club, which includes art institutions around the world. Could a Web site this sophisticated really be the work a 13-year-old girl? Who is the real Mouchette? The true identity of the artist behind *http://mouchette.org* remains unknown.

The Mouchette persona and Web site are loosely based on Robert Bresson's 1967 film, "Mouchette", about a suicidal adolescent girl who is raped in a forest at night. A quiz likening the site to the film once appeared online, but after Bresson's widow threatened to take legal action against the artist behind the project, the quiz was taken offline. It has since appeared on one of many Web sites created in response to the project. These range from celebratory spin-offs to angry attacks. Clearly, *http://mouchette.org* provokes heated reactions to its portrayal of child sexuality and to the way it constructs and manipulates identity online. *http://mouchette.org*'s use of feminine disguise can be likened to Cindy Sherman's *Untitled Film Stills*, in which Sherman posed in photographic self-portraits as archetypal Hollywood heroines. But whereas Sherman's work explores the performative nature of identity through portraiture, Mouchette does so through the sometimes playful, sometimes provocative interactions she sets up with her visitors.

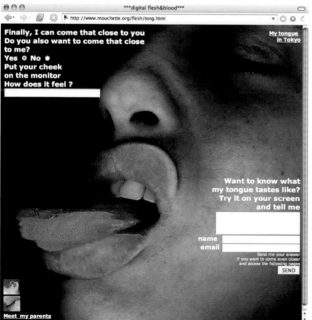

Mouchette.org, 1996 – ongoing

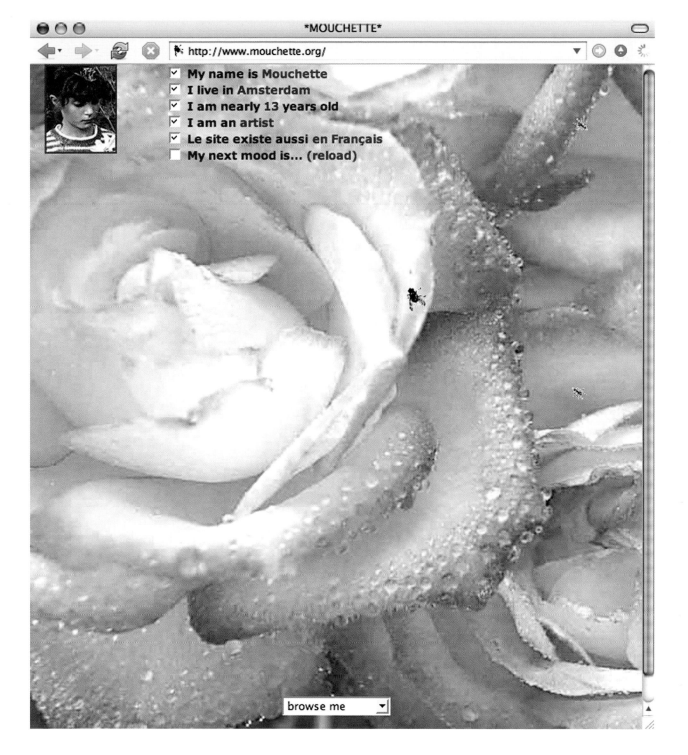

http://www.mouchette.org/

- ☑ **My name is Mouchette**
- ☑ **I live in Amsterdam**
- ☑ **I am nearly 13 years old**
- ☑ **I am an artist**
- ☑ **Le site existe aussi en Français**
- ☐ **My next mood is... (reload)**

browse me

1 year performance video (aka samнsiehupdate)

CSS, Flash, JavaScript, MySQL, PHP, XHTML
Keywords: algorithmic, conceptual, performance, process, time
http://turbulence.org/Works/1year

The work of MTAA (M.River & T.Whid Art Associates, founded in 1996) exemplifies the processual nature of most Net art. The duo, whose online identities are M.River and T.Whid (their real names are Mike Sarf and Tim Whidden), illustrates a process-based approach in *Simple Net Art Diagram* (1997), a basic GIF animation that shows two computers connected by a line and a flashing red lightning bolt. A text placed near the bolt reads "The art happens here", emphasizing that Net art, like Process art, Performance art and Happenings, is less an object for contemplation than an event or action that takes place over time.

MTAA makes a direct link to their art-historical predecessors in an ongoing body of work that they call "Updates". In these projects, the artists reinterpret seminal art works from the 1960s and '70s by using new technologies to perform actions that defined the original pieces. In one "Update", MTAA revisited On Kawara's date paintings, in which the artist painted each day's date on canvas as part of a project that continued for many years. Instead of painting block letters and numbers to form minimal compositions, as Kawara did, MTAA utilized a software programme to display the current date on a Web page in Kawara's signature style, reducing countless hours of labour to a few hours of a programmer's time.

A particularly ambitious "Update" is MTAA's *1 year performance video (aka samHsiehUpdate)*, which revisits Tehching (Sam) Hsieh's *One Year Performance 1978–1979 (aka Cage Piece)* and adapts it in various ways to the Internet age. In the original work, Hsieh spent an entire year living within a cage, documenting his self-induced confinement with photographs. In MTAA's online version, viewers observe what appears to be live video footage of the artists, each occupying a small, cell-like room – waking up in the morning, eating and reading during the day and sleeping at night. In fact, the footage consists of pre-recorded clips selected according to the time of day one visits the site. The clips are edited dynamically to generate streams of video that are customized for each viewer. If one watches for an entire year – a daunting task – one becomes an official "collector" and is given a unique data file that documents the performance in code. In Hsieh's original work, the burden of the process was on the artist. MTAA shifts this burden from artist to viewer. At the same time, the duo changes the stakes for collectors, who must commit time instead of monetary resources in order to acquire the work – a clever twist on the adage "time is money".

1 year performance video (aka samHsiehUpdate) can be seen as a comment on the increasing replacement of human activities and live experiences with those executed or mediated by computer hardware and software. This project is also a deftly transparent demonstration of New Media's ability to manipulate our perceptions of time and of our increasingly sceptical relationship toward visual evidence as an index of reality.

Simple Net Art Diagram

The art happens here

MTAA ca. 1997

Simple Net Art Diagram, 1997

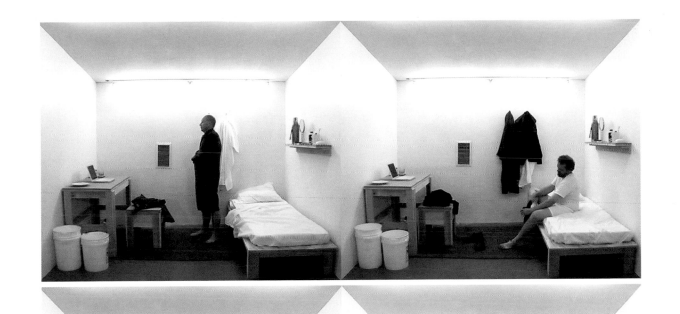

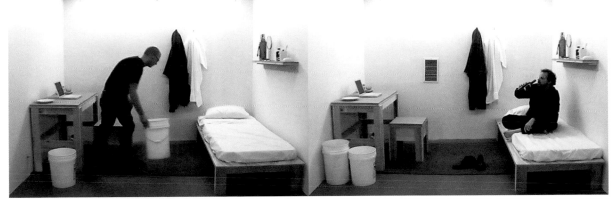

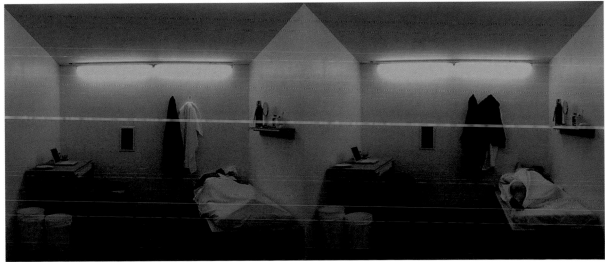

shredder 1.0

HTML, JavaScript, Perl
Keywords: algorithmic, formalist, interactive, remix
http://www.potatoland.org

What we see when we browse the Web is a carefully designed veneer, an orderly facade that conceals the jungle of code used in its making. Mark Napier's *Shredder 1.0* lets us peek behind the curtain, revealing a colourful jumble of text and images. Enter a Web address in the location field at the top of *Shredder 1.0*'s Web interface, or choose from one of two dozen pre-selected URLs, and the *Shredder* literally deconstructs the original site, slicing and dicing its text, imagery and source code to form abstract compositions.

Shredder 1.0 works by passing the code in which a Web page is written through a Perl script, a rudimentary programme that parses and rearranges the original code before handing it on to your Web browser. Napier wrote the Perl script in such a way that the results are always visually similar – the signature style of the algorithm that produced them. Although traces of the original site's design and content can sometimes be identified in the distorted logos and fragments of text that remain, the shredded versions more closely resemble the non-representational paintings of Hans Hoffmann or Gerhard Richter than the slick interfaces of the Web

sites from which Napier's compositions derive. Napier's approach to Net art reflects his own background as a painter; the images that *Shredder 1.0* generates demonstrate a refined awareness of colour and shape. Hoffmann and other Abstract Expressionists reduced painting to its intrinsic formal characteristics, such as the flatness of the picture plane and the plasticity of paint. Napier draws our attention to the fundamental technological properties of the Internet, from the complexity of code to the variability of images.

Like many of Napier's later works, including *Landfill* (1998), and *Feed* (2001), *Shredder 1.0* is both interactive (in that it requires us to provide or select the address of a Web site to shred) and generative (in that it runs an algorithmic process that produces the work anew each time). "My works are not objects but interfaces. The users become collaborators in the art work, upsetting the conventions of ownership and authority", Napier writes in an artist's statement. "By interacting with the work, the visitors shape the piece, causing it to change and evolve, often in unpredictable ways. The user is an integral part of the design."

Napier extends this notion of collaborative interaction to his collectors in *Waiting Room* (2002), a Software art project that the artist describes as a "moving painting". In this project, user input (ideally via a wall-mounted touch screen) produces abstract shapes and renditions of shadows and walls. Napier has worked with Bitforms, a New York gallery devoted to New Media art, to offer to collectors 50 ownership shares in the work. Collectors receive a copy of the art work on a CD-ROM. Each instance of *Waiting Room* is connected to the others via the Internet, so that when one collector interacts with the work, the resulting forms appear on every collector's screen.

Waiting Room, 2002

The Pink of stealth

5.1 surround sound system, AC3 decoder, DVD player, Flash, HTML, JavaScript, MP3 stream, video projector
Keywords: game, identity, hypertext, interactivity, narrative
http://www.blacknetart.com/pink.html

As the Internet first gained popularity in the mid-1990s, some cultural theorists argued that it was part of a new kind of virtual space (sometimes called cyberspace) that we enter as disembodied subjects whose identities are malleable and disguisable. Our bodies are left behind along with our genders, races and ethnicities. In this new environment, the cyberpundits suggested, our flesh-and-blood bodies don't register because they're not visible. If a teenage girl could masquerade as a middle-aged man, or vice versa, it seemed that the old rules of identity politics no longer applied.

Others contended that our embodied identities follow us onto the Internet, and that categories such as female, white, or hispanic were every bit as real online as off. In Mendi and Keith Obadike's *The Pink of Stealth*, colour takes on multiple meanings related to race, class and health. The colour pink becomes a sign for whiteness in this multilayered project, which combines an online hypertext work, a Web-based game and an audio mix that is available online as an MP3 and also on DVD in surround sound.

The hypertext conveys the story of a man, Mark, and a woman, Randi, whose races are never revealed, although Mark is described as a sophisticate who likes to drink, and Randi as a woman with a "less than rosy" life who has "colour in her cheeks". Randi seeks a wealthy mate who is able to provide a "red-blooded, blue-eyed heir". This may or may not be Mark, who wishes to see Randi's "true colours". The plot unfolds in a non-linear way through five variations, each revealing only a few fragments of the text. Each numbered variation opens in a pop-up window against a pink background (a different shade each time). The fifth variation, for example, shows the following text fragments scattered across the screen: "a/strange/time/in a crowd/of/hunters". Each variation strings together words and phrases from the text to form a new sentence, unveiling an encoded meaning.

In the animated game, *Fox Hunt* (2003), a fox is chased by a hound and a brown-skinned figure on horseback, dressed in the uniform of an English country gentleman-hunter. The game is accompanied by the sound of two mbiras (African thumb pianos).

The mbiras appear again in the sound mix, along with a fox whistle and a recording of the entire hypertext piece read aloud by a female narrator. Points accrue at the top of the screen next to the words "uneatable" and "unspeakable", referring to a quote from "A Woman of No Importance" ("The unspeakable in full pursuit of the uneatable"), Oscar Wilde's play about hidden identity and Victorian society – one of several wide-ranging literary and cinematic references that also include "Pretty in Pink", a 1980s teen-movie about a rich boy who dates a poor girl. In *The Pink of Stealth*, the Obadikes weave such diverse sources together to explore the relationship between the language of colour and the complexities of race and class.

"The phrase 'in the pink' (also used in the form 'in the pink of health') comes from the English foxhunting culture of the 18th century. At that time, Thomas Pink was the favoured fashion designer of the aristocracy and fashionable hunters were said to be 'in the pink': that is, in Thomas Pink's (red) hunting jackets. Though Thomas Pink stores are still around, his name does not register in popular culture as it did a couple of centuries ago. However, the language around his fashions and other values of the time continue to pervade our speech. we use this project to think about the associative properties of language and the way that a word or concept from one context can carry along the values of another context."

Mendi and Keith Obadike

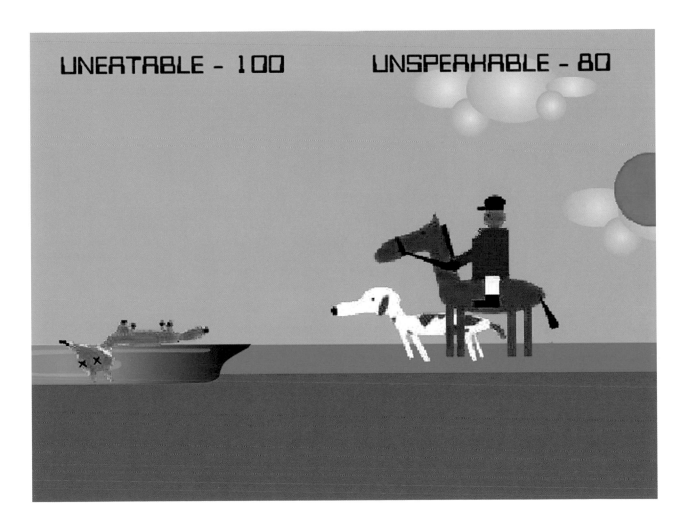

Free Radio Linux

Micro FM transmitter, Oddcast Ogg Vorbis encoder, REALbasic
Keywords: open source, performance, sound
http://www.radioqualia.va.com.au/freeradiolinux

On February 3, 2002, to commemorate the fourth anniversary of the coining of the term "open source", a duo calling themselves radioqualia (Honor Harger, a former Webcasting curator at the Tate Modern in London, and Adam Hyde, an electronic musician and software developer from New Zealand) launched *Free Radio Linux*, an audio distribution of Linux, a popular open source operating system. Like other open source software, Linux is developed and improved by a distributed network of volunteer programmers who freely share the fruits of their labour. The most successful open source software project of its time, Linux was favored by many New Media artists, from RSG to Raqs Media Collective, and served as a model for open source cultural practices of all kinds.

radioqualia programmed a "speech.bot" (software that converts text into a synthesized human voice) to recite all 4,141,432 lines of the source code of the kernel, or core, of the Linux operating system. The speech.bot's output was then encoded using Ogg Vorbis, an open source audio codec, or compression-decompression scheme. The voice was broadcast over the Internet in real time, and relayed to a network of FM, AM and Shortwave radio stations around the world. *Free Radio Linux* was inspired in part by the "code stations" of the 1980s – pirate radio broadcasts of bootleg programmes that were converted by modems into noise, played over the air, then reconverted by listeners' modems into working software. In theory, a *Free Radio Linux* listener could transcribe each line of the Linux kernel's code, or cut and paste it from the text that accompanied the reading (presented so that people could follow what they were hearing in the audio stream).

The speech.bot's reading was a kind of spoken-word performance that continued 24 hours a day for 590 consecutive days. To sit and listen non-stop to this automated spoken-word performance would have been beyond the limits of human endurance. In this regard, *Free Radio Linux* echoes such durational New Media art works as John F. Simon, Jr.'s *Every Icon* and MTAA's *1 year performance video (aka samHsiehUpdate)*. In each of these projects, computers replace artists in the execution or performance of the work. Lines of code such as "Segment #8, Start Address 00ff003b, Length 3, 0xff, 0x00, 0x3b, 0x00, 0x03, 0x00, 0x02, 0x00, 0x3b" bring to mind both Kurt Schwitters' Dadaist experiments from the 1920s and 1930s, in which the artist used phonetic sounds as raw material in nonsensical yet poetic recordings, and the British band Radiohead's use of a robotic voice on their 1997 album "OK Computer".

Free Radio Linux exemplifies the non-commercial nature of much New Media art. By deliberately operating outside the marketplace and embracing open source methods of production and distribution, radioqualia offers an implicit critique of the proprietary economies of both the art world and the software industry. *Free Radio Linux* nonetheless received the support of Minneapolis' Walker Art Center, an established art-world institution.

"In the hierarchy of media, radio reigns. There are more computers than modems, more phones than computers and more radios than phones. Radio is the closest we have to an egalitarian method of information distribution. 'Free Radio Linux' advocates that radio is the best method for distributing the world's most popular free software."

radioqualia

FREE RADIO LINUX
FREE RADIO LINUX
FREE RADIO LINUX

FREE
RADIO
LINUX

- README
- ./listen
- ./cron
- ./config
- ./comments
- ./changelog
- ./credits
- ./etc

README

001 – What Is It ? –

002 **Free Radio Linux** is an online and on-air radio station. The sound
003 transmission consists of a computerized reading of the code used to
004 create the operating system, Linux.

005 **Free Radio Linux** is an audio distribution of the **Linux Kernel**, the basis
006 for all versions of Linux operating systems. Each line of code will be read
007 by the computerised automated voice - a speech.bot built by r a d i o q u a
008 l i a. The speech.bot's output will then be encoded into an Open Source
009 audio stream (using the codec, **Ogg Vorbis**), and sent out live on the
010 internet. A selection on FM, AM and Shortwave radio stations from around
011 the world will also relay the audio stream on various occasions.

012 The Linux kernel contains **4,141,432 lines of code**. Reading the entire
013 kernel will take an estimated 14253.43 hours, or 593.89 days. **Free Radio**
014 **Linux** begins transmission on February 3, 2002, the fourth anniversary of
015 the term, Open Source.

016 Listeners can track the progress of **Free Radio Linux** by listening to the
017 stream, or checking the text-based progress field in the ./listen section.

018 – Background : Linux and Open Source
019 – Free Radio meets Free Software
020 – Concept

———>
nextfile

OPUS

Apache, GD, ImageMagick, Linux, MySQL, PHP, Smarty
Keywords: appropriation, collaboration, interface, open source
http://www.opuscommons.net

OPUS (Open Platform for Unlimited Signification) is an online digital commons for sharing creative work and an example of an important genre of New Media art – projects that create an environment where artists submit their work and, in doing so, contribute to a larger gesamtkunstwerk of sorts. A complex and ambitious project with utopian aspirations, *OPUS* encourages artists and authors to upload their own original source files to appropriate media objects found within the system (including images, video, audio, text and software code). Participants may then produce what Raqs Media Collective calls "Rescensions" by remixing or otherwise altering these found sources and contributing their new works back into the *OPUS* system. Each media object is tagged in an online database with extensive metadata, such as keywords and descriptions, that facilitate search and retrieval. Although much of this information is displayed as text, *OPUS* also includes a visualization feature that represents media objects as colour-coded icons connected by arcs and circles showing the relationships between objects. Raqs uses genetic inheritance as a metaphor to describe how source files ("parents") and derivative works ("children") are related. As they write on the *OPUS* Web site, "A Rescension is neither a clone, nor an authorised or pirated copy nor an improved or deteriorated version, of a pre-existing text, just as a child is neither a clone, nor an authorised or pirated copy, nor an improved or deteriorated version of its parents."

With its emphasis on appropriation, collaboration and sharing, *OPUS* is modelled after open source software development, in which source code is made freely available to programmers who collaboratively author software on a share-and-share-alike basis. This approach to cultural practice, known as open source culture or free culture, has been on the rise since the early 20th century, driven in part by the proliferation of technologies of mechanical and digital reproduction and distribution. From Dada to Pop and from found footage film to hip hop, appropriation has become an increasingly important strategy for artists of all stripes.

Raqs is based in India, where the high-tech industry had become an important engine of economic development by the early 21st century. Within the continuum of South Asian art history, the *OPUS* project is evocative of the multiple points of view in Mughal paintings. The name Raqs can be read in two ways: it is a word used in Persian, Arabic and Urdu to describe the frantic state experienced by dervishes as they dance, and it suggests the English acronym FAQ, for "frequently asked questions" – although, as New Media curator Steve Dietz points out, "rarely asked questions" could more accurately describe Raqs' mode of critical inquiry.

"'OPUS' seeks to build a creative commons with a community of media practitioners, artists, authors and the public from all over the world. Here people can present their own work and make it open for transformation, besides intervening and transforming the work of others by bringing in new materials, practices and insights. The discussion forums are there to open out the works to comments and reflections. 'OPUS' follows the same rules as those that operate in all free software communities – i.e. the freedom to view, to download, to modify and to redistribute. The source(-code), in this case the video, image, sound or text, is free to use, to edit and to redistribute."

Raqs Media Collective

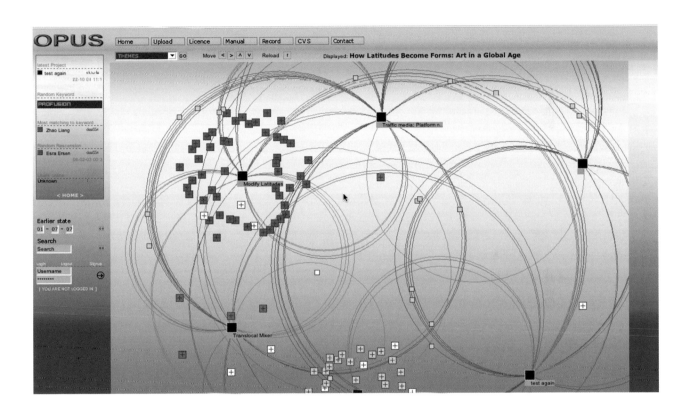

carnivore

C, Director, Flash, Java, libpcap, Objective-C, PacketX, Perl, Pd, Processing, tcpdump, Visual Basic, winpcap
Keywords: hacktivism, Software art, surveillance, tool, collaboration
http://www.rhizome.org/carnivore

Computer networks empower us to share information, but they also make it easier for governments and corporations to monitor our electronic communications. In the 1990s, the United States' Federal Bureau of Investigation (FBI) used a digital wiretapping software application called Carnivore to surveil traffic flowing through the servers of Internet service providers. This Orwellian technology enabled agents to read email messages and eavesdrop on the chat-room conversations of ordinary citizens. In response to this high-tech form of state surveillance, a loose-knit team of artists calling themselves RSG, for Radical Software Group, developed *CarnivorePE* (PE signifies "Personal Edition"). RSG was founded by Alex Galloway in 2000 and is named after "Radical Software", a magazine about experimental video published in the 1970s.

CarnivorePE is a Software art project that uses an open-source tool called a packet sniffer to listen in on the network on which it is installed. Like the FBI's ominously named Carnivore, *CarnivorePE* invisibly detects the packets of data that make up emails sent and received, text and images posted online and Web sites browsed by individuals on the network. But the similarity ends there. Whereas the FBI uses its surveillance software to spy on suspected criminals, RSG uses the data harvested by *CarnivorePE* as raw material for artistic interfaces, called "clients", which are produced by a variety of New Media artists. Like other works of New Media art, such as Raqs Media Collective's *OPUS*, *CarnivorePE* functions as a platform or tool for artists.

Clients developed for *CarnivorePE* include the abstract *Amalgamatmosphere* (2001), by Joshua Davis, Branden Hall and Shapeshifter, a Flash interface in which brightly hued translucent circles represent each active network user. The colour of each circle reflects a specific activity: deep green if someone is using AOL, for example, or dark blue for Web-surfing.

Other *CarnivorePE* clients emphasize the political implications of network surveillance. For example, *Guernica* (2001), by the New Media art duo Entropy8Zuper!, envisions the network as a dystopian world, a barren globe rendered in black and white. Planes orbit the planet, representing fragments of email mes-

sages. Other types of data are visualized as rockets, buildings, oil pumps and roads. The work's title and monochromatic palette derive from Picasso's painting *Guernica* (1937), a disturbing cry against the violence of war.

Police State, a *CarnivorePE* client by Jonah Brucker-Cohen, is a physical installation in which a fleet of modified toy police cars move in response to keywords associated with terrorism. According to the artist, "the data being 'snooped' by the authorities is the same data used to control the police vehicles. Thus the police become puppets of their own surveillance." Like the other *CarnivorePE* clients, *Police State* transforms surveillance from a covert activity into an artistic spectacle.

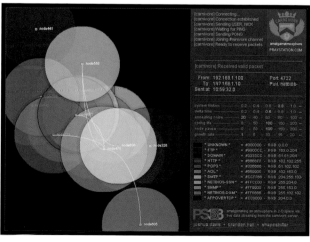

Amalgamatmosphere, 2001

RADICAL SOFTWARE GROUP

0003-2

Sat, 21 Apr 2001 18:26:47 -0400

To: ███████████████

Re: an update on Carnivore..

i've successfully installed a new backend for Carnivore. here
are the details.

* the backend is now running ███████████████ i
was having some problems with ████████████ seems to
work fine, so i'm using that instead. ████ as much better
features too.

* the backend is no longer ██████████████████

* i am starting to work on a frontend interface. ████████

So the real question now is *security*. ████████

my slution to the security issue is this:
 * ████████████████
 * ████████████████

Sincerely,

7E-1 ██████████████

www.rtmark.com

Constructor, HTML, SiteBuilder
Keywords: corporate parody, hacktivism, prank, collaboration
http://www.rtmark.com

In 2000, the Whitney Biennial included Net art for the first time; one of the nine online projects selected for exhibition was that of the art-activist group ®™ark (pronounced "art mark" and sometimes spelled RTMark). At the Whitney, the featured Web sites were exhibited on a single computer and projected onto a gallery wall. When museum-goers accessed *http://www.rtmark.com*, they didn't see the group's regular Web site, which serves as an archive of past and current projects and mimics the language and graphics of corporate sites. Instead, visitors witnessed a revolving showcase of sites – such as The Backstreet Boys' home page, a Christian university's site and a pornography outlet – submitted to the group by friends and fans. ®™ark's rebellious act of inclusion could be seen both as a portrait of the Internet at that particular moment in 2000 and as a series of Duchampian readymades.

Subversion is ®™ark's modus operandi. Like other New Media art collectives, such as Etoy, ®™ark's members have largely remained anonymous so they can freely engage in socially conscious sabotage. The artists emphasize the ®™ark brand over their own individual identities in a parody of corporate brand-consciousness. As an actual corporation, ®™ark benefits from the same limitation of liability that protects business owners from legal damages. In other words, ®™ark's corporate status allows its members to promote and participate in anti-corporate and anti-governmental actions without the worry of financial risk or ruin.

The group's provocative actions have indeed sparked legal threats. In 1998, for example, ®™ark helped fund a CD of allegedly illegal resamplings of Beck songs, "Deconstructing Beck", which was met with an angry letter from Beck's record label. And in 1999, ®™ark launched *GWBush.com*, a highly convincing spoof of George W. Bush's 2000 presidential campaign Web site, GeorgeWBush.com. ®™ark's site mocked Bush and instructed site visitors to conduct informal polls and submit the results to the Bush camp. The *GWBush.com* site prompted not only a cease-and-desist letter, but also Bush's comment "there should be limits to freedom".

With their widespread visibility and influence, ®™ark has helped support other New Media art projects, including Etoy's *Toywar*, a battle against corporate giant eToys' spurious lawsuit to stake a claim to the eToy name. Raising funds for these activities by such imaginative means as auctioning on eBay their tickets to a celebratory dinner for the 2000 Whitney Biennial, ®™ark uses commercial and institutional channels in their critiques of systems of power.

®™ark Boardroom, 1998

> **"®™ark is indeed just a corporation and benefits from corporate protections, but unlike other corporations, its 'bottom line' is to improve culture, rather than its own pocketbook; it seeks cultural profit, not financial."**
>
> ®™ark

Email | Home

New projects **Past projects** **Material** **World**

Dow-Chemical.com

Yes Men as WTO

Voteauction.com

CueJack

The etoy Fund

GWBush.com

Reamweaver

Gatt.org

Archimedes

Art Inspection

Deconstructing Beck

 Feb. press release

 press

 nasty letters

 ALPA letter

 April press release

Phone In Sick Day

FloodNet

Secret Writer's Society

Popotla vs. Titanic

B.L.O.

SimCopter

The Y2K Fund

Other past projects

General press

February 17 press release | Past projects / Deconstructing Beck / Feb. press release

FOR IMMEDIATE RELEASE
February 17, 1998

Contacts: info@rtmark.com
(http://www.rtmark.com/)
 illegalart@detritus.net

(http://www.detritus.net/illegalart)

RTMARK FINDS BUCKS FOR BECK RIP-OFF
Group channels money for subversion,
hopes to spark dialogue on corporate wrongs

RTMark is pleased to announce the February
17 release of a new Beck CD: *Deconstructing
Beck*.

Recording artist Beck might be less
pleased. Why? Because it isn't really his
work. *Deconstructing Beck* is a collection
of brilliant but allegedly illegal
resamplings of Beck, produced by Illegal Art
with the help of $5,000 gathered by RTMark
from anonymous donors.

velvet-strike

Counter-Strike, Dreamweaver, DVD, HTML, Photoshop, paint, Wally
Keywords: game, hacktivism, intervention, tactical media
http://www.opensorcery.net/velvet-strike

In the late 20th century, technologies used by both the U.S. military and the entertainment industry began to converge in video and computer games. American pilots and other military personnel trained in combat simulators featuring highly convincing digital graphics. In battle, they often experienced the real world through the mediating interfaces of game-like targeting and navigation systems. At the same time, increasingly realistic games known as "first person shooters" featured immersive, three-dimensional worlds in which players engaged in violent conflicts, depicted with near-photographic realism. After September 11, 2001, the artists Anne-Marie Schleiner, Joan Leandre and Brody Condon were both fascinated by and critical of an internationally popular first-person shooter called Counter-Strike, in which players choose to undertake either terrorist or counter-terrorist operations in an urban environment. The artists saw the game as an overly simplistic "convergence of network shooter games and contemporary Middle Eastern politics in a game… that leaves out a number of complexities such as economics, religions, families, food, children, women and refugee camps".

When playing Counter-Strike (a "mod", or modification, of another extremely popular first-person shooter called Half-Life), multiple players connect via the Internet to occupy the same virtual environment, fighting with or against one another in teams and communicating through text messages and voice channels. In addition, players can upload images to insert in the game space as "spray paints", or graffiti tags, to commemorate a kill or mark territory. *Velvet-Strike* is an artistic intervention that enables participants to insert what the artists call "counter-military graffiti" into the virtual space of Counter-Strike. These range from phrases like "hostages of military fantasy" to images of terrorists and counter-terrorists embracing. The project's title invokes the Velvet Revolution of 1989, in which protests in Czechoslovakia led by the playwright Vaclav Havel resulted in the bloodless overthrow of that country's communist government.

The *Velvet-Strike* Web site also includes instructions that serve as recipes for performative interventions within Counter-Strike. The prescribed processes suggest how players might stage virtual protests using game figures. One set directs a group of players to gather in a heart-shaped formation while repeatedly sending out the chat message "Love and Peace" and stoically refusing to move or return fire. These directions recall instructional art works of the 1970s like Yoko Ono's *Draw a Map to Get Lost*.

In addition, the site features screen-capture movies showing sprayers in action and examples of hate mail from Counter-Strike players angered by the artists' provocative actions, which some fans of the original game interpreted as denouncing video game violence. Schleiner, Leandre and Condon, however, have made it clear that *Velvet-Strike* is not critical of violence in video games, per se. Instead, the work prompts us to wonder what exactly is at stake in the fictive virtual worlds in which both soldiers and civilians immerse themselves, at a time when real-life warfare increasingly resembles games, and games increasingly resemble real life.

"Reality is up for grabs. The real needs to be remade by us."

Anne-Marie Schleiner, Joan Leandre and Brody Condon

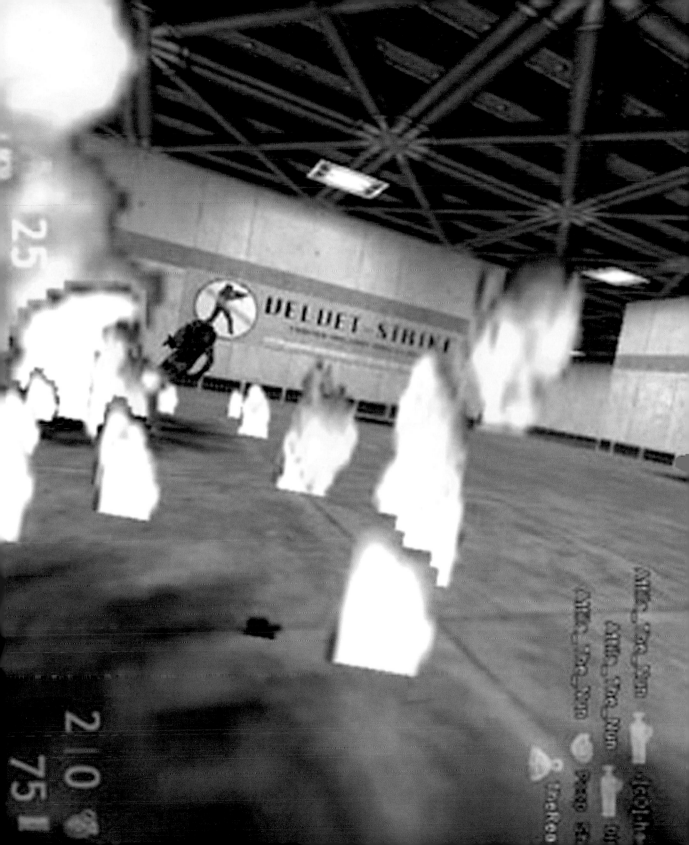

386 DX

386 DX processor, 4 Mb RAM, 40 Mb hard disk, sound card
Keywords: appropriation, cyberpunk, music, performance, pop
http://www.easylife.org/386dx

Although the term "cyberpunk" was initially used to describe a genre of network-centric science fiction by such authors as William Gibson and Neal Stephenson, the word also applies to the computer music of Moscow-based artist Alexei Shulgin. On his Web site, Shulgin describes his ongoing project *386 DX* as "the world's first cyberpunk rock band." Yet instead of a group of musicians, Shulgin's "band" consists of one antiquated computer with an Intel 386 DX processor running text-to-speech and MIDI (Musical Instrument Digital Interface) software. Shulgin wields the computer keyboard like a rock star would an electric guitar, performing synthesized versions of familiar pop songs ranging from the 1960s hit "California Dreamin'" by the Mamas and the Papas to Nirvana's 1990s grunge anthem, "Smells Like Teen Spirit". Shulgin's versions of these songs sound like a robot singing karaoke to early video game soundtracks.

Shulgin's concerts have taken place in a variety of live venues including hip London bars and the San Diego/Tijuana border – with Shulgin on the U. S. side and the machine on the other. *386 DX* has also played autonomously, without Shulgin. On the sidewalks of Graz, Austria, passersby left monetary tips, as if the computer were a street musician. In 2000, Shulgin published "The Best of 386 DX" as an enhanced CD. In addition to cover tunes from his repertoire, the disk includes the software Shulgin used to produce them (along with a bootleg copy of Windows 3.1, the operating system the software runs on). With this disk, fans can run *386 DX* on their personal computers to relive the experience of a *386 DX* performance.

Before *386 DX*, Shulgin had made a name for himself as one of the principal early practitioners of Net art. In 1994, he co-founded the Moscow WWWArt Centre, a Web site devoted, in the artist's words, to "the highest possible level of art/life uncertainty". One project hosted at the Centre was the *WWWArt Award*, a medal given to found Web pages that, according to Shulgin, were "created not as art works but gave us definite 'art' feeling". In this early online art project, one can already see evidence of the distinct Pop art sensibility that emerged fully in *386 DX*, an infatuation with mainstream culture tinged with artistic aloofness. Live musical performance was a logical next step for Shulgin, who saw Net art as a performative practice in which making a work, discussing it, and presenting it were all part of the work itself.

Like Cory Arcangel's *Super Mario Clouds*, *386 DX* is simultaneously ironic and nostalgic, taking a humorous and playful approach to New Media art. Both artists use outmoded technologies to poke fun at the international, profit-driven cult of the new that characterizes the information-technology marketplace and consumer culture. Like Paul Miller aka Dj Spooky That Subliminal Kid, Shulgin approaches musical performance as a conceptual art practice, bridging the worlds of fine art and popular entertainment.

MIDI Concertino for 386 DX, 1999

aLife

15" PowerBook G4, C, OpenGL, XCode
Keywords: artificial life, generative, object, software
http://www.numeral.com/panels/alife.html

Although he works primarily with software code and pixels rather than paintbrushes and pencils, New Media artist John F. Simon, Jr. often cites the early 20th-century painter and draftsman Paul Klee as a major influence on his practice. Simon's 1996 work, *Every Icon*, echoes a process described in Klee's seminal book on drawing, "Pedagogical Sketchbook" (1925). In this short text, Klee describes his attempt to study the combinatorial possibilities of patterns and structure by filling in the squares of a grid drawn on a piece of paper. Simon reinterprets Klee's experiment in *Every Icon*, a Java applet (a small programme that runs in a Web browser) that executes the following terse algorithm: "Given: An icon described by a 32 X 32 grid. Allowed: Any element of the grid to be coloured black or white. Shown: Every icon."

After calculating the computer's processor speed, the applet begins with an image in which every square is white and proceeds to display every possible combination of black and white squares until each square is black. Along the way, it will draw all possible images that can be represented by a grid of 1,024 squares. The huge number of possible combinations means that, even running on a computer showing 100 icons per second, it would take more than a year to display all variations of the first line of the grid, and more than five billion years to complete the second line. Recognizable images would not begin to appear for several hundred trillion years. Eventually, however, the applet would draw every possible icon, realizing a computational version of Klee's combinatorial grid. "While *Every Icon* is resolved conceptually", Simon writes on his Web site, "it is unresolvable in practice." Because of its mind-boggling duration, *Every Icon* is as much a thought experiment as it is a work of Net art.

In 1998, Simon took apart and reassembled a laptop computer to make a self-contained version of *Every Icon* that would become the first in a series of what he calls "art appliances." These wall-mounted objects are intended for gallery exhibition and function as software-driven, animated paintings. One such "art appliance" is *aLife*. This work features a grid of six continuously changing three-dimensional compositions. Each abstract animation is generated in real time by software, which models the emergent, recombinant processes of living evolutionary systems. Simon used a variety of sources, including hand-drawn forms and scanned maps, to create images that resemble scientific diagrams of subatomic structures, planetary systems and microscopic organisms (not to mention Modernist design objects like George Nelson's "Ball Clock"). Although *aLife* is much more complex and colourful than *Every Icon*, both projects exemplify the importance of coding in Simon's work (the artist always writes all of his software code himself). For Simon, the software itself is as much a part of the art work as the images it produces. His iterative, experimental coding process is a way of exploring possibilities and capitalizing on accidents.

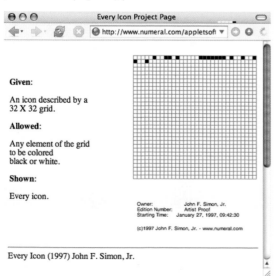

Every Icon (1997) John F. Simon, Jr.

Every Icon, 1996

Female Extension

HTML, email servers, Perl
Keywords: cyberfeminism, hacktivism, intervention, tactical media
http://artwarez.org/femext

In 1997 – the year Vuk Cosic coined the term "net.art" and documenta X, the highly regarded exhibition of contemporary art, included Internet-based work for the first time – the Hamburger Kunsthalle – Galerie der Gegenwart announced that it would be "the first museum in the world" to host an international Net art competition. The museum called the project "Extension", suggesting that online presence for the institution constituted a virtual wing in cyberspace. The competition's organizers made it clear that only works created specifically for the Internet (as opposed to work in other media presented on the Web) would be considered. Despite their evident curatorial sophistication, the organizers failed to realize that more than 200 of the 280 entries they received were submitted by faux female Net artists, all produced by a single piece of software as part of a tactical intervention by the cyberfeminist artist Cornelia Sollfrank. She dubbed her act of deception *Female Extension*, a play on the term for an electrical receptacle.

For *Female Extension*, Sollfrank fabricated names, nationalities and phone numbers for women from seven different countries – and provided working email accounts with various Internet service providers to cover her tracks. She registered each of these artists as a competitor for the "Extension" prize, prompting the Hamburger Kunsthalle to issue a press release announcing that 280 applications had been received, two-thirds of them from women. To create individual works of Net art for each of her spurious entries, Sollfrank's software scanned the Web for existing HTML material and remixed the data and imagery to fashion ersatz works that vaguely resemble the HTML deconstructions of Jodi.

Although Sollfrank flooded the competition with phony female entrants, none of her alter-egos won. In fact, although thanks to Sollfrank the majority of the contestants were female, all three prize winners were male – a result Sollfrank attributes to the widespread sexism that biases the selection of artists for exhibitions. It is this discrimination that Sollfrank intended to critique in *Female Extension*, a key work in the history of Cyberfeminism, a movement that emerged in the mid-1990s to address the dominance of men in the online world and the technology industries as a whole. According to Sollfrank, Cyberfeminism is characterized by its use of irony to join humor and seriousness as political and artistic strategy. In an appropriately ironic twist, one of the judges for "Extension" was the 1970s Feminist artist Valie Export.

When the three winners of "Extension" were made public, Sollfrank sent out a press release exposing her previously covert actions. Expanding on *Female Extension*, Sollfrank later developed the programme used to create each submission as its own, independent art work consisting of random elements culled from existing sites. Bluntly titled Net Art Generator, this art-making machine functions in a manner that recalls Jean Arp's Dada collages, created by throwing torn paper onto a surface to make compositions that conveyed the aesthetics of chance.

Female Extension, 1997

"cyberfeminism is not just a rhetorical strategy, but also a political method."

Cornelia Sollfrank

since May. 01 3045

2001

Digital still cameras, custom software, data projectors
Keywords: media archaeology, time, Web cam
http://www.thing.net/empire.html

In 1991, years before the Internet became an everyday word and a widespread form of communication, German sculptor Wolfgang Staehle founded The Thing, an electronic bulletin board system (BBS) that functioned as a forum for artists and cultural theorists who dialled in via modem to discuss their work and exchange ideas. Like a 1920's Montparnasse cafe, The Thing was a lively creative community where debates raged and collaborations were formed. In 1995, Staehle migrated The Thing to the World Wide Web, and in subsequent years expanded its services to include Web site hosting and development. Yet despite these practical aspects of The Thing, the project as a whole can be seen as a Beuysian social sculpture, a participatory space in which the boundaries between artistic practices and everyday activities is blurred.

In 1999, for the "net_condition" exhibition at the ZKM Center for Art and Media in Karlsruhe, Staehle set up a digital camera in The Thing's office, which was located on a high floor in New York's West Chelsea neighbourhood, and pointed the lens at the Empire State Building. He captured images of the building every few seconds and transmitted them via the Internet to the ZKM, where they were projected on a gallery wall. Staehle titled the installation *Empire 24/7* in reference to Andy Warhol's *Empire* (1964), an eight-hour-long film in which the camera focuses on the Empire State Building from dusk until dawn. Like Warhol, Staehle frames the Empire State Building in a prolonged static shot that draws attention, through the absence of action and camera movement, to the structure of the tower itself, to the effects of light on the building and in the sky and to the act of viewing itself. Although both works explore the representation of time, Warhol's structural film is an exercise in extreme duration, whereas Staehle's Web cam work reflects the temporal compression of Internet communication. According to Staehle, *Empire 24/7* is about "instant images for instant consumption". Staehle's project shows how the ubiquity of Web cameras have produced a Warholian environment in which even the most mundane scene is available to anyone with Internet access, at any time, anywhere – 24 hours a day, 7 days a week. Staehle's projection created the impression of a virtual window, as if one could see through the Karlsruhe museum's gallery wall directly into New York City. *Empire 24/7* is thus also a visceral demonstration of the way in which the Internet collapses physical distances.

Staehle continued to work with Web cameras in gallery installations featuring multiple large projections of outdoor tableaux that function as live landscape paintings. In September 2001, Staehle presented *2001*, an installation at Postmasters Gallery in New York that included three Web camera views: a castle-like monastery near Stuttgart, the looming TV tower in Berlin's Alexanderplatz and lower Manhattan. The latter Web camera captured the attacks on the World Trade Center in real time, briefly transforming the work into the Internet-age equivalent of a history painting.

Empire 24/7, 1999

The Region of the Transborder Trousers (La región de los pantalones transfronterizos)

3DS Max, data projector, GPS, MaxScript
Keywords: data visualization, installation, locative, surveillance
http://www.torolab.co.nr

At the turn of the 21st century, artists began to experiment with Global Positioning System (GPS) devices that track, via satellite, our movements in physical space. In *The Region of the Transborder Trousers (La región de los pantalones transfronterizos)*, Torolab, a Tijuana-based collective of architects, artists, designers and musicians led by Raúl Cárdenas Osuna, use GPS transmitters to explore the logistics of daily life in the twin border cities of Tijuana and San Diego. This project not only makes visible the transnational mobility of the region's inhabitants, but also demonstrates the artistic potential of locative technologies.

For a period of five days, members of the collective carried GPS transmitters, wore Torolab-designed garments including a skirt, a vest, two pairs of pants and sleeves that could be worn with t-shirts, each with a hidden pocket for a Mexican passport. They also kept records of their cars' fuel consumption. The GPS and fuel data was then fed into a computer and visualized (using software reprogrammed by Torolab) as an animated map. Each tracked Torolab member appeared as a coloured dot on an urban grid surrounded by a circle whose diameter indicated the amount of fuel left in his or her tank. In 2005, *The Region of the Transborder Trousers* was presented as an installation at ARCO, a contemporary art fair in Madrid. The installation featured a large, floor-mounted topographical relief map of the Tijuana/San Diego area, onto which the animated map was projected from above. The animation compressed several days' worth of locative data into an eight-minute loop (about 900 times faster than real time), tracking each member as he or she navigated the area's vast urban sprawl.

With more than 100,000 daily crossings, the Tijuana/San Diego border is one of the busiest in the world. Like Heath Bunting and Kayle Brandon's *BorderXing* (2002), an online guide to secretly crossing international boundaries for those lacking the requisite papers, *The Region of the Transborder Trousers* exploits the border, with its endless traffic jams and humiliating searches as an opportunity for creative experimentation. *The Region of the Transborder Trousers*, however, seizes the border primarily as an opportunity for aesthetic experience rather than overt political critique. In a similar vein, Torolab's *Vertex Project* (1995–2000) is a proposal for a fibreglass-and-steel pedestrian bridge that would span the Tijuana/San Diego border and function as a giant multimedia display. Participants would submit images and texts via an on-site computer for projection onto the bridge's two billboard-size screens, transforming the bridge into a grassroots artistic spectacle.

Torolab was founded by Cárdenas Osuna in 1995 as a "socially engaged workshop committed to examining and elevating the quality of life for residents of Tijuana and the trans border region through a culture of ideologically advanced design". Torolab's "utopian quest for the 'sublime in the quotidian'" brings to mind the work of such Russian Constructivist artists as Vladimir Tatlin, who in the 1920s experimented with architecture and clothing design under the slogan "art into life".

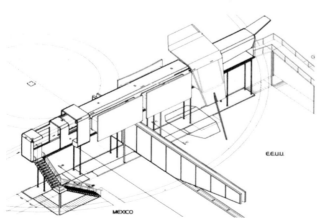

Vertex Project, 1995–2000

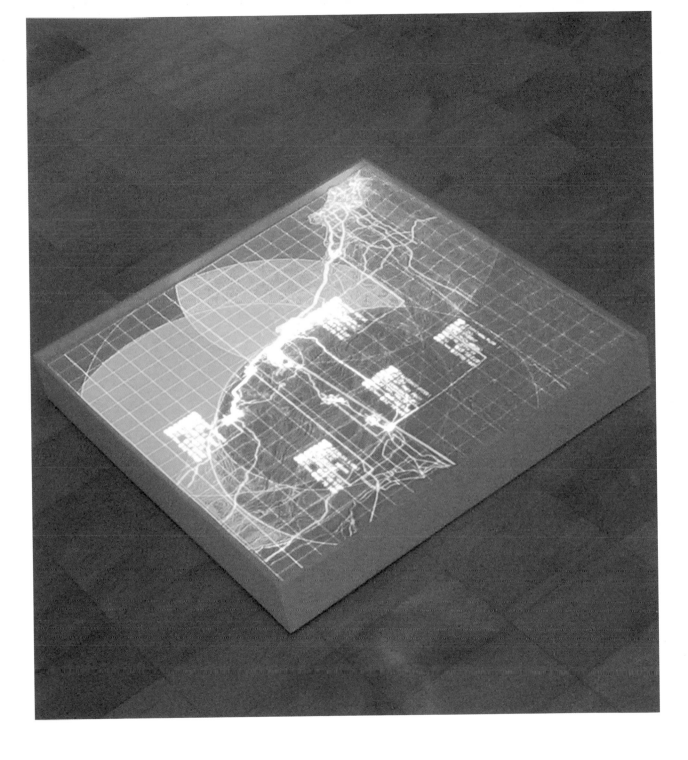

BUST DOWN THE DOOR AGAIN!
GATES OF HELL-VICTORIA VERSION

Flash, metal structure, Samsung Internet refrigerators, sound system
Keywords: cinema, concrete poetry, installation, narrative, remix
http://www.yhchang.com/GATES_OF_HELL.html

==

In 1999, Young-hae Chang, a Korean artist with a Ph.D. in aesthetics from the Université de Paris I, and Marc Voge, an American poet based in Seoul, participated in a Net art workshop organized by Multimedia Art Asia Pacific, in Brisbane, Australia. They focused on Flash, a powerful Web animation tool that can take years to master. By the second day, they had learned two of this tool's basic features: how to make text appear on the screen and how to set an animation to music. Like Nam June Paik discovering video, a form that would define his artistic practice, Chang and Voge had found their medium. Under the name YOUNG-HAE CHANG HEAVY INDUSTRIES, they produced a series of fast-paced text movies in which words set to jazz appear in rapid succession in the web browser window, filling the screen. The texts offer dramatic stories – written by Chang and Voge in several languages – of sex, violence, alienation and the insignificance of human life. Rather than emphasizing sophisticated uses of new technologies at the sacrifice of strong writing, Chang and Voge present texts that are engaging and effective, written in a convincing voice.

BUST DOWN THE DOORS! (2000) tells the tale of a midnight raid on a home by unidentified armed aggressors: "They bust open the door while you sleep, rush into your home, enter your bedroom, drag you out of bed, push you in your underwear out into the street…" The point of view begins in the second person, then shifts to first and third person, offering various perspectives on the narrative.

In 2004, YOUNG-HAE CHANG HEAVY INDUSTRIES produced *BUST DOWN THE DOOR AGAIN! GATES OF HELL-VICTORIA VERSION*, a remix in which the original text appears in red, superimposed over a photograph of their work as it was displayed on nine Internet refrigerators for an exhibition in the Rodin Gallery at the Samsung Museum of Art in Seoul. The artists "thought that an Internet refrigerator would be an unusual way of presenting Net art. Advertisers would have us believe that the Internet refrigerator puts the housewife at the cutting-edge of modern, hi-tech life. We titled our piece THE GATES OF HELL

because, on the contrary, we feel that their refrigerator helps keep women in the kitchen."

Most New Media art employs interactivity to engage us as participants in the work. YOUNG-HAE CHANG HEAVY INDUSTRIES eschews interaction, but the result is hardly a passive experience. By accelerating the pace at which the text appears to a rate just within the threshold of human cognition, the artists coax us into a state of rapt concentration. *BUST DOWN THE DOORS!* is remarkable for its ability to produce a strong, visceral impact with limited means.

YOUNG-HAE CHANG HEAVY INDUSTRIES' work is closely related to both concrete poetry and experimental cinema. A connection to film history is explicitly signalled by the artists' consistent use of a title screen that reads "YOUNG-HAE CHANG HEAVY INDUSTRIES PRESENTS", as well as a numerical countdown that is similar to those preceding early movies.

THE
DOOR

BUST DOWN THE DOORS!, 2000

DØØR

To stay informed about upcoming TASCHEN titles, please request our magazine at www.taschen.com/magazine or write to TASCHEN America, 6671 Sunset Boulevard, Suite 1508, USA–Los Angeles, CA 90028, contact-us@taschen.com, Fax: +1-323-463.4442. We will be happy to send you a free copy of our magazine which is filled with information about all of our books.

© 2007 TASCHEN GmbH
Hohenzollernring 53, D–50672 Köln
www.taschen.com

Editorial coordination: Sabine Bleßmann, Cologne
Design: Sense/Net, Andy Disl and Birgit Reber, Cologne
Produktion: Tina Ciborowius, Cologne

Printed in Germany
ISBN 978-3-8228-3041-3

Photo credits:
The publishers would like to express their thanks to the archives, museums, private collections, galleries and photographers for their kind support in the production of this book and for making their pictures available. If not stated otherwise, the reproductions were made from material from the archive of the publishers. In addition to the institutions and collections named in the picture descriptions, special mention is made of the following:
p. 2: Courtesy Postmasters Gallery, New York
p. 4: Photo Martin Vargas
p. 8: Courtesy PaceWildenstein, New York
p. 14: Photo © Museum of Contemporary Art, Chicago, Photo Michael Raz-Russo
p. 21 left: Dia Center for the Arts, New York
p. 52: Photo Peter Cunningham

Reference illustration:
p. 78: *Amalgamatmosphere*, 2001, a CarnivorePE client by Joshua Davis, Branden Hall and Shapeshifter

page 1
ANNE-MARIE SCHLEINER, JOAN LEANDRE AND BRODY CONDON

Velvet-Strike
2002, Counter-Strike, DVD, HTML
http://www.opensorcery.net/velvet-strike

page 2
JENNIFER AND KEVIN MCCOY

Every Shot/Every Episode
2001, 277 DVDs with sound, carrying case, DVD player, LCD monitor

page 4
RAFAEL LOZANO-HEMMER

Vectorial Elevation
1999, interactive artwork designed to transform the Zócalo square in Mexico City. Using a three-dimensional interface the website of the artist allowed the visitor to design a light sculpture with 18 robotic searchlights located around the plaza.
http://www.alzado.net